2009 11 23

Fine Art Digital
Nature Photography

Fine Art Digital
Nature Photography

TONY SWEET

STACKPOLE
BOOKS

Published by
STACKPOLE BOOKS
5067 Ritter Road
Mechanicsburg, PA 17055
www.stackpolebooks.com

Printed in China

10 9 8 7 6 5 4 3 2 1

First edition

Cover design by Caroline M. Stover

Library of Congress Cataloging-in-Publication Data

Sweet, Tony, 1949–
 Fine art digital nature photography / Tony Sweet. — 1st ed.
 p. cm.
 ISBN-13: 978-0-8117-3494-3
 ISBN-10: 0-8117-3494-3
 1. Nature photography. 2. Photography—Digital techniques. I. Title.
TR721.S925 2009
779'.3—dc22

 2008025805

For Susan, Kelly, and Akira,
for their love and support;
and to my parents, Mary and the late Emil Sweet,
who passed on to me a deep passion and relentless work ethic,
making it possible to follow and realize my dreams.

Foreword

*Don't ever begin to believe
that when you get to a certain
point, you're there.*

*Don't ever put a limit to what
you want to be, because when
you get to that place, you're
nowhere.*

*Don't ever set yourself a
stopping place, because maybe that
is just the beginning.*

—artist/writer John Held, Jr.

THESE KNOWING WORDS BY JOHN HELD CONTAIN THE ESSENCE OF *FINE ART Digital Nature Photography*, in this latest of Tony Sweet's contributions to the creative process. We, who are seekers on a creative journey, who never want to stop, who never want to know limits, are offered seeds of possibilities for new exploration and deeper self-discovery. Tony invites us to dive into the creative sea, to be lost in fantasy, and to wander in play and potential.

There are many ways to interpret and express individuality on a creative journey. In *Fine Art Digital Nature Photography*, Tony presents threads of ideas and directions to form an artful weaving of technique and imagination. With easy-to-follow diagrams and explanations, Tony suggests solutions that eliminate some of the frustration we can encounter with digital techniques, and shares his visual perceptions through dreamy, sensual, and often painterly interpretations.

There are no limits in creative adventures. There are only new ways to nourish our creative appetites—to help us to stay alive and excited about the

possibilities in photography and in the creative process. Tony's work and technique incite a passion—a vitality—a freedom from inhibitions—an unabashed, unapologetic means to expression.

It often takes courage to try new techniques and challenges—to leap into the unknown—to move beyond fear into unfamiliar territory. This book forces your creativity, and by the very act of leaping you transform into an alive and awake photographer who invites growth and desires to express feelings. The spirit of adventure and playfulness permeates these chapters. Each page is an invitation to create images that wouldn't have existed without the involvement of your unique perception of the world.

In addition to being an extraordinary photographer, Tony is a master musician. I feel music in Tony's photography. His personal vision is akin to his musical talents as he transforms the reality of the world into artistic symphonies. He creates and orchestrates his photographic images as he would a musical band. Courageously, he embraces the spirit of exploration, composing images for all to appreciate.

You too can create your own photographic symphonies with the techniques and ideas that Tony shares. If you listen mindfully and tune in to the instruction, this book will provide resources for communicating intimate expressions of who you are and how you see and feel as a creative soul. Your photography can then become a venue for expressing your feelings and revealing the hidden essence or true nature of your subjects.

Fine Art Digital Nature Photography will awaken your creativity and bring you to many beginnings, where you will dance with the deeper transcendental quality that creativity brings to your work and to your life. As you experience the joy of discovery, you honor the creative poet that lives within and is yearning to be alive. As you explore and discover, you celebrate the person who you are and your ability to interpret perceptions of this amazing world we are all so privileged to share.

—*Nancy Rotenberg*
www.naturaltapestries.com

Nancy's creative teachings can be found in her latest book, *Photography and the Creative Life*, and her DVD, *Let Your Light Shine.*

Foreword

TONY SWEET'S IMAGES ARE CONSISTENTLY CAPTIVATING AND BEAUTIFUL.
As cameras have become more sophisticated and automated, more and more
laypeople are able to capture passable images. With histograms providing
immediate information, it's easier to be sure that you're not missing the expo-
sure. But Tony's images go far beyond "passable" and correctly exposed—they
are often magical and mystical. I always love to look at Tony's latest work and
I never fail to be inspired by his creative eye.

In this book, Tony gives you a glimpse behind the scenes and shares some
of his secrets. He describes in detail the steps he took to capture his original
images and how he optimizes them into their final forms. This is not a theo-
retical approach to image optimization: it is a down-to-earth, step-by-step
description of what he did. He offers a well-balanced blend of the artistic
elements and the technical elements.

Those who are already comfortable with their expertise in photography
and Photoshop are still likely to pick up some new tricks and tips. Given that
there are lots of ways to arrive at similar results using the various digital soft-
ware programs currently available, it's helpful to see exactly how a master such
as Tony works with his images. Although I consider myself to be quite profi-
cient in Photoshop, I too picked up a few tips!

It is evident that Tony is not only a wonderful photographer, but also a
filter guru with both hardware and software filters. I was familiar with most
of the hardware filters he uses, but, until I read this book, I had little appre-
ciation for the immense creative potential offered by some of the software
filters. In my experience, I often come across images that overuse filters and
look too gimmicky for my taste. Tony's use of software filters enhances the
image in ways that truly convey the original intent and feeling. The end
result is images that are expressive and extraordinary.

Without a doubt this is a book you will pick up repeatedly to be inspired time and time again to go beyond the ordinary and take your images to the next level.

—*Ellen Anon*
www.ellenanon.com

Ellen is coauthor of *Photoshop CS3 for Nature Photographers: A Workshop in a Book* and *Aperture Exposed: The Mac Photographer's Guide to Taming the Workflow*. She is a member of the Apple Aperture Advisory Panel.

Prelude

THE CHALLENGE IN WRITING *FINE ART DIGITAL NATURE PHOTOGRAPHY* WAS to come up with a book that would have a longer shelf life than eighteen months. Given the rapidity with which software and hardware are evolving, this is certainly a challenge.

Photography—even digital photography—is all about the image. This book will set forth to discuss and illustrate some digital techniques and the use of Photoshop plug-ins. This is not a software intensive book, although there are certainly software techniques included, but it is a book illustrating what anyone can do to add interest to an image using minimal software intervention. It is common knowledge that an effect can be accomplished any number of ways through the use of software and even, in some cases, in-camera techniques.

There are basically two schools of thought in digital photography. One focuses on getting as much right in the camera before pressing the shutter, and the other foregoes all of the up-front work (e.g., color correcting filters, graduated neutral density filters, panning, multiple exposures, etc.), preferring to create or replicate those effects in software. And, of course, there is a middle area where you perform some of the tasks when taking the image, but previsualize software intervention when making the image. Like an ever-increasing number of photographers, I fall into the middle area.

The digital transition is a defining issue in photography and will continue to be in the future. The transition from film-based media to digital media involves learning new, and constantly changing, hardware and software. The learning curve can be intimidating and may result in a long time lag before you enter into the digital world. Unfortunately, the longer you wait to transition to digital, the further behind you'll get. This is particularly true in the stock photography business, where all of the major stock agencies only accept digital files (45MB or larger) or drum scans. (Unless you own a drum or Imacon scanner, this is an impractical option.) The only practical answer is to take a deep breath and jump right into buying a professional digital camera. Fortunately, prices for pro-level Digital Single Lens Reflex cameras (DSLRs) are constantly coming down, and the speed, megapixels, and file

quality are increasing with each successive line of pro-level digital cameras. You will also need professional image-editing software (Photoshop), RAW processing software to read and adjust your RAW files (Adobe Camera Raw, Aperture), cataloging software to organize your extensive files (Aperture, Lightroom, Expression Media 2), and any plug-ins (Nik Software, Alien Skin Software) that will speed up the editing process. If you aspire to print your own photographs, you'll need calibration software. Actually, digital printing requires that all hardware "sees" color the same way for accuracy. Ideally, the monitor should look like the finished print or very close to it, but monitor calibration software is not enough. You not only need to calibrate your monitor, but you also need to use profiles for the specific printer and paper that you are using. The leap from a color-corrected monitor image and a finished print that looks like what you're seeing on the monitor requires special calibration software, such as X-Rite's Eye One. You can make your own custom profiles or purchase them.

There is certainly a learning curve with software and hardware. Taking classes or having an accessible mentor to answer questions and help you get the ball rolling is essential. There are no quick fixes or secret handshakes to lessen the angst or speed up the process when transitioning to the brave new world of digital photography. The process of learning and relearning constantly updated hardware and software demands an open and flexible approach.

After learning how all this stuff works, you may wonder how it all works together to create an efficient workflow. The way you define your workflow depends on what you want to do with your photography. I have two different workflows for processing images: one to get images ready for stock submission and one for printmaking. I use Aperture, but Lightroom has many similar characteristics. Without making any image adjustments, I copy the contents of my flash card to a DVD for backup and direct them to a project created and named for the session. After this, I edit and keyword. Stock images are exported from Aperture at the proper file size, set up in the export criteria. Individual images selected for print are opened, edited, and printed through Photoshop.

With all of the various imaging software out there, you can go a little nuts, not to mention spend a lot of time (and money!) trying out and even purchasing numerous software packages, and you probably won't get beyond the "handshake" usage stage with many of them. Although this is a necessary process, you have to make a decision somewhere along the line and settle on software packages that work best for you and stick with them for a while.

After going through that expensive and time-consuming process myself, here are the software packages I use and why I use them:

Aperture v2.0—This latest version of Aperture is fast, sleek, and has enough editing controls to contain the workflow within Aperture, versus importing an image into Photoshop to make minor adjustments. It's an excellent "all-in-one" program for image processing, cataloging, keywording, and storage.

Adobe Photoshop CS3—This is the industry standard software for image editing. We print through Photoshop, and I also use it to add creative effects, like digital sandwiching, and for applying plug-ins.

Nik Software—Practically every image I make is run through a Nik filter, Viveza U-point, Dfine noise reduction, and Nik Sharpener. All images are sharpened using Nik Sharpener. Color Efex gives you a battery of useful and creative filter options to express your personal vision and interpretation. We prefer Nik Sharpener to other sharpening methods after comparing several. It's fast, clean, and the effect can be customized based on image size, paper type, viewing distance, and printer resolution.

Alien Skin Software—Snap Art recreates various media effects, like watercolor, oil paint, pen, and ink. Alien Skin also makes Exposure 2, which emulates various film types.

Expression Media (formerly iViewMedia)—This is excellent cataloging software. I find it quite useful when producing quick presentations for workshop critiquing.

Eye One—This is used to calibrate monitors, printers, and digital projectors. We also create our own custom paper profiles.

Since spending time at the computer is an essential part of image-making in the digital age, I look for software that is fast, simple, powerful, and has a clean and easily understandable interface. Don't forget that the "fast" part of this is more a function of processor speed and the amount of RAM.

Being from the "film era," I have two prime criteria: to get it right as much as possible in the camera (with some software previsualization) and to produce images that have the look of Velvia ISO50, which was the image standard for nature/outdoor photographers in the twenty years before the advent of digital.

In addition to Nik's Color Efex Pro filter set, I still use several glass and resin filters. The reasons will be discussed throughout the image examples.

Unlike my previous three books—*Fine Art Nature Photography*, *Fine Art Flower Photography*, and *Water, Ice and Fog*—all of the images in *Fine Art Digital Nature Photography* are digital captures, all shot in RAW using Nikon professional DSLRs.

Since very few of us are software gurus, it is the intent of this book to illustrate how a few simple plug-ins and software tips and tricks can enhance an image to what we see in our imaginations. The blending of digital technology and photographic skill can work together, opening up to the photographer new vistas of creative expression.

—*Tony Sweet*, April 2008

Seek the strongest color effect possible . . . the content is of no importance.

—Henri Matisse

One of the truly great things about digital photography is that it gives you the ability to experiment to your heart's content and then immediately check out the results on the camera's LCD. You can then fine-tune your idea or pitch it if it completely misses the mark and try something else. This is particularly good for multiple exposures and "swiped" images, which may require several attempts and adjustments before coming up with a keeper.

Of course, if you need to, you can also use the LCD to check composition. The LCD alone, however, is not an accurate tool to judge exposure and contrast, although it gets better with each successive camera generation. Your histogram is the tool to check your exposure and to make sure that your highlights aren't blown out.

This image is created using a technique that I refer to as a "swipe." It's performed using a shorter exposure, such as $1/8$ second, $1/15$, $1/20$, etc. It works best at $1/2$ second or less. It takes a little practice, but you actually move the camera quickly during your exposure. The movements can be upward, downward, diagonal, in a semicircle, a quick hook, or even using the shape of some of the letters of the alphabet. These images almost always lose reference to the true subject; however, the motions can create interesting color abstracts. This image, made at $1/15$ second, was swiped in a quick right to left "C" pattern. If you look closely at the image, you'll notice the "C" lines. After trying the initial swipe idea, I kept honing the movement to increasingly quicker and smaller movements until I achieved this abstract painterly image. The subject is a path of many different colored azaleas.

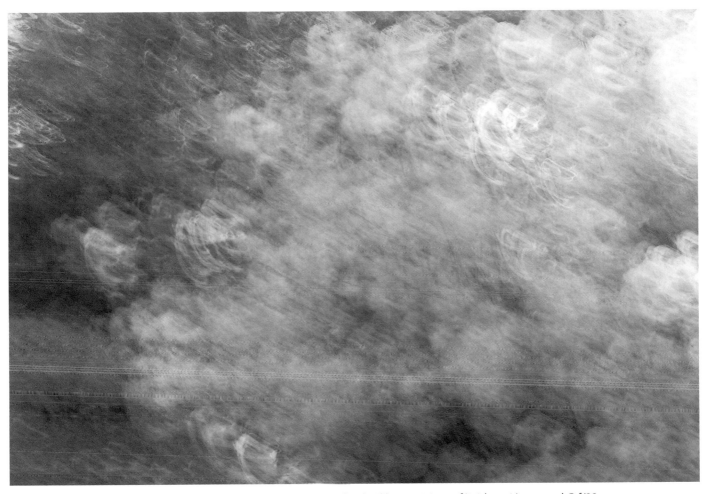

Azalea row, Brookside Gardens, Wheaton, Maryland; Nikkor 35–70mm, f/2.8 lens; $1/15$ second @ f/22

Technique—Camera Swipe

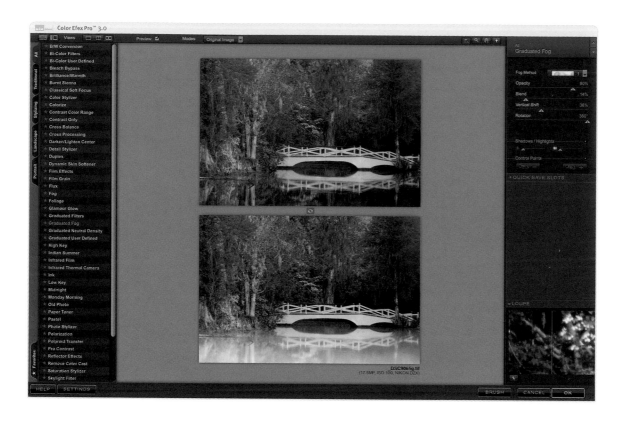

The original scene of the footbridge and mirror reflecting pond at Magnolia Gardens, South Carolina, was quite nice. However, I felt that it needed something else. Being out in nature quite a bit, we see recurring situations. Given the temperature and the bright sunrise, I was hoping for a thin mist across this small pond. It didn't occur, so having used Nik's graduated filters in the past, I made the mental connection to use the Graduated Fog filter, but to reverse it, so that it came up from the bottom. After adjusting the rotation and the vertical shift to cover only the water up to the bridge, blend and opacity were adjusted to taste to achieve what I felt should have been the scene.

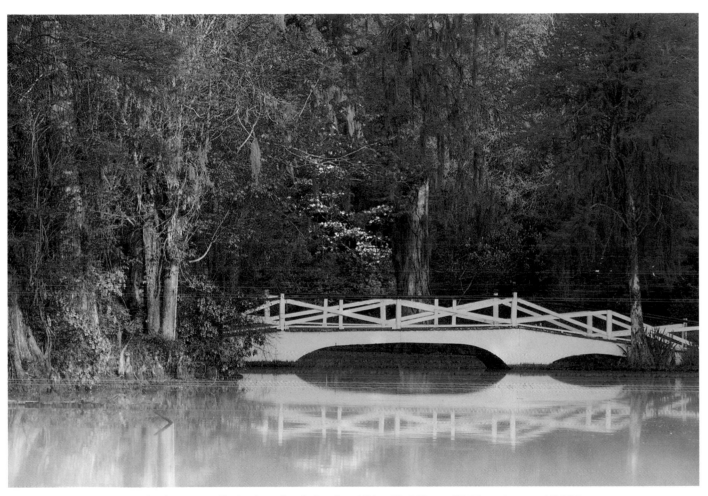

Footbridge, Magnolia Gardens, South Carolina; Nikkor 70–200mm, f/2.8 lens; 1 second @ f/22
Technique—Nik Graduated Fog Filter

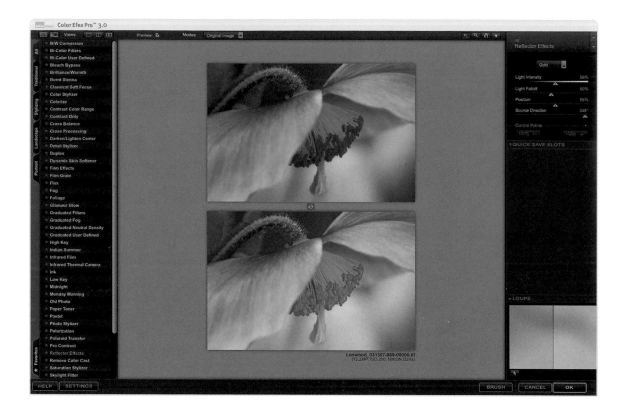

Some subjects cannot be reached easily with a reflector for any number of reasons. In this case, the African blue poppy is in a fragile area in an indoor conservatory. I had to use a 300mm lens with an extension tube to get this composition. Getting closer with a shorter lens was not practical without the possibility of damaging the surrounding flowers. The flower was facing downward and a reflector was needed to add some light to the dark underside (stamen area). Placing a reflector under the flower was impossible, as the lens was too far away for me to operate the camera and to hold the reflector. The Nik Color Efex Pro Reflector: Gold filter worked out well in this situation. I was able to adjust the software controls to manage the light as I would have if using a real reflector. As you can see, the Reflector: Gold filter affects the entire image. As I only wanted to lighten the underside stamen, I chose the Paint option from the bottom right menu and brushed in the effect to the chosen area.

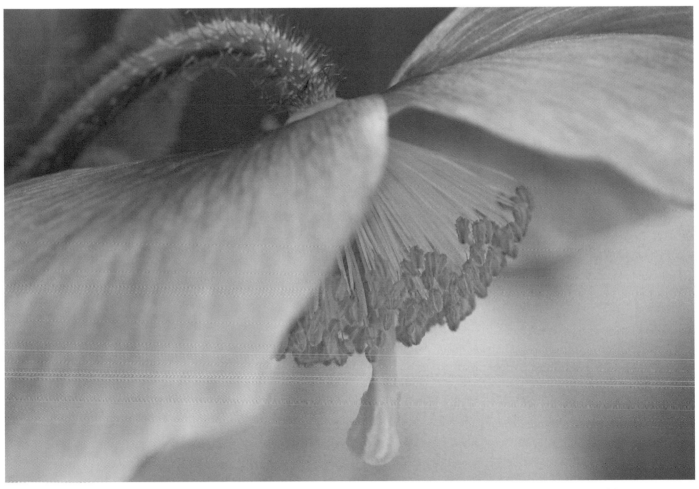

African blue poppy, Philadelphia, Pennsylvania; Nikkor 300mm, f/4 lens with a 36mm extension tube; ¹/₂ second @ f/11

Technique—Nik Reflector: Gold Filter

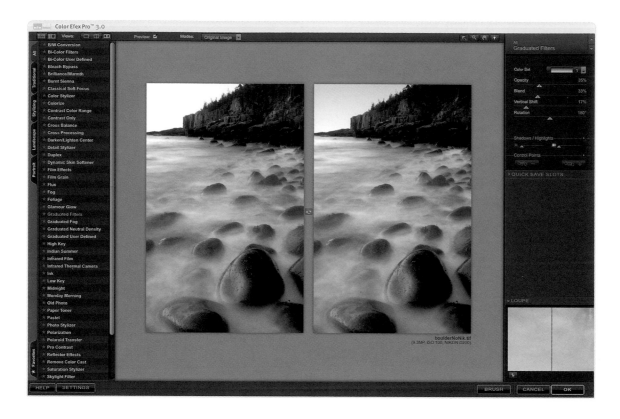

Digital camera sensors, much more than film, are very sensitive to highlights. Consequently, subtle, pastel colors can get lost in digital photography, and digital methods often have to be used to replicate what you saw when taking the picture. This is a situation that happens so often that I've learned to previsualize how an image will look after being processed in software.

Since the area of sky was jagged, using a traditional graduated neutral density filter may have rendered an uneven tonality, encroaching on the cliff and trees. Using the Nik Graduated: Blue filter was an excellent tool to remedy this situation. After adjusting the vertical shift, blend, opacity, and selecting my preferred color set, I chose the Paint option in the menu box and then painted the pastel blue sky into the open sky area only. Occasionally, the painted effect will be too strong. Rather than redoing the effect, adjusting the opacity in the layers palette will solve the problem.

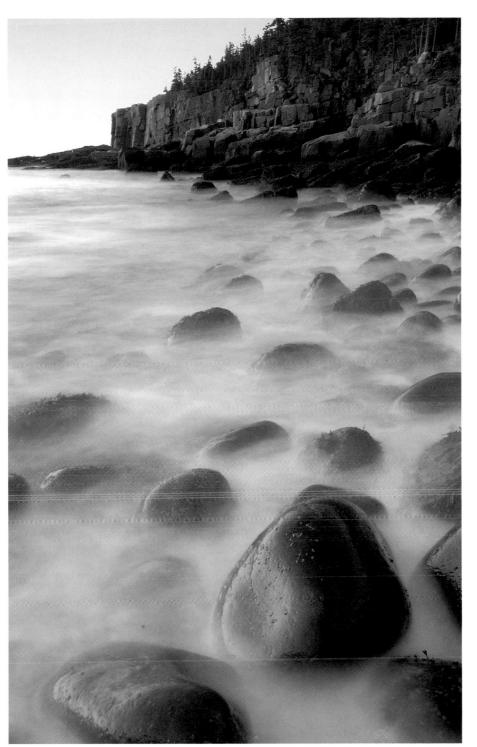

Acadia National Park, Maine;
Nikkor 17–35mm, f/2.8 lens;
15 seconds @ f/22

*Technique—Nik Graduated:
Blue Filter*

The emotions are sometimes so strong that I work without knowing it. The strokes come like speech.

—Vincent Van Gogh

A long exposure pan of trees is one of my favorite abstract interpretations, especially if there is something else going on in the scene. In this case at Cypress Gardens, about forty miles from Charleston, South Carolina, we had a particularly crisp and foggy morning. As you can see, the RAW file is a bit flat, which is not unusual because "raw" means just that: all data is recorded with no in-camera enhancements. This is actually good. RAW gives the photographer ultimate command of the final image, since all of the subsequent enhancements are made by the photographer with no image degradation.

Since these types of images are basically abstract images, there is leeway to alter the image to the photographer's taste. As you can see from the adjustment layers in the Hue/Saturation box above, I dramatically increased the overall saturation to 30 (after trying larger and smaller increments). I then created a small S-curve, which increases overall contrast. The combination of these two adjustment layers rendered the image to my satisfaction.

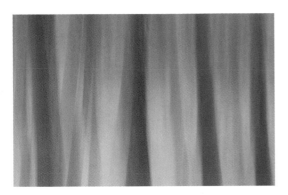

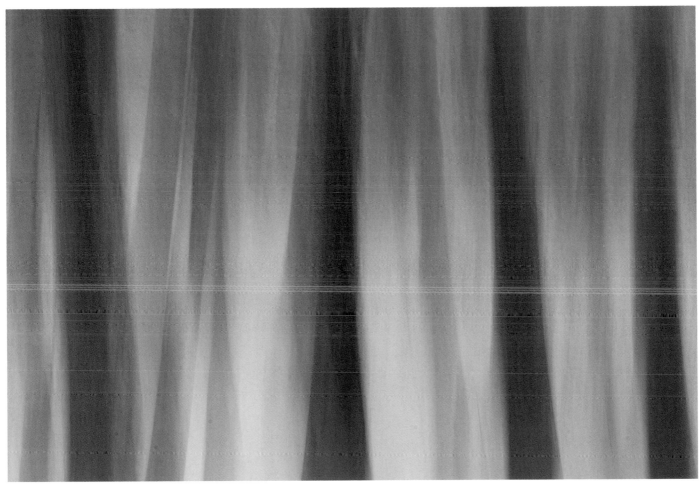

Bald cypress trees abstract, Cypress Gardens, South Carolina; Nikkor 70–20mm, f/2.8 lens; 1 second @ f/22

Technique—Panning

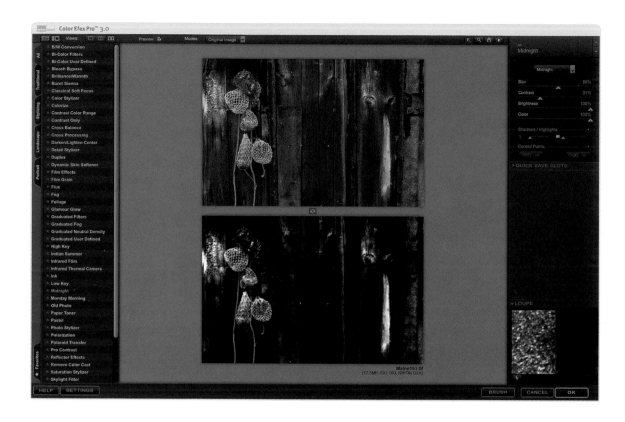

One of my favorite types of Nik filters is the Midnight series. Applying the effect greatly increases contrast, similar to a sandwich (a technique that will be discussed in detail later). The most important thing to notice in the Midnight filter control panel is that the brightness was up to 100 percent, which I apply to every image on which I use this filter. I tend to want to oversaturate these types of special effects, so the color in Midnight was also set to 100 percent, which greatly affected the richness of this image, especially the reds. Aside from setting the brightness to 100 percent, all other controls vary depending on the subject.

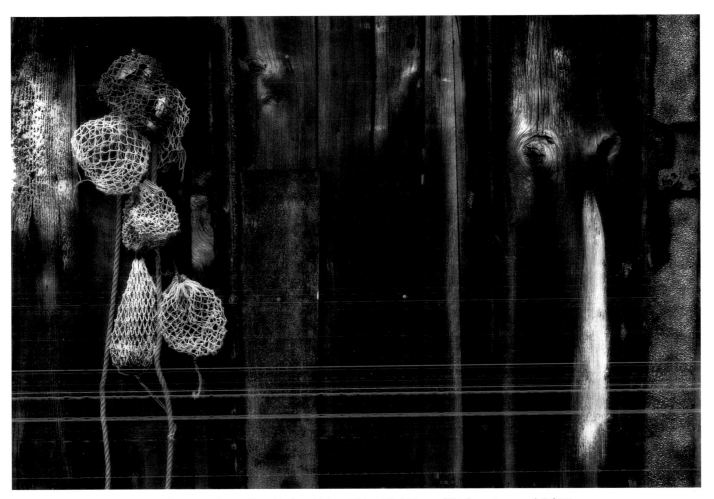

Boat house and nets, New Harbor, Maine; Nikkor 70–200mm, f/2.8 lens; 1 second @ f/22

Technique—Nik Midnight Filter

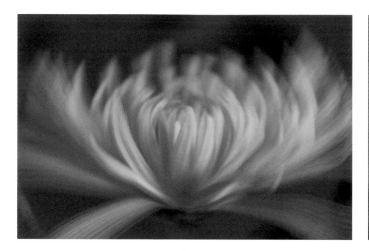

1 2

This is a very cool effect created in-camera using the image overlay and the multiple exposure custom functions in the Nikon professional cameras. Image 1, above, is a ten-exposure multiple image, made by very slightly twisting the 200mm macro lens in its loosened tripod collar. The smallness of the movements is well seen at the bottom right part of the frame in the thin petal. Being able to inspect the image immediately upon shooting, I shot several multiples to get exactly the right feel, some detail and some blur, but somewhat sharp in the middle. Image 2 was shot wide open and defocused. I took several different exposures with various levels of defocus, and then I selected the soft image that worked best with the multiple exposure image. Then I combined the images in-camera using the Image Overlay function and varied the opacity of each image until I attained the proper balance between the two images to get the look I saw in my imagination.

This effect can also be achieved using cameras that do not have the image overlay and multiple exposure functions. You will need to shoot the multiple exposures as separate files, and then combine them in Photoshop using layers, as in the previous image. That will create a look almost identical to image 1. Then just shoot the second image wide open and defocused, appearing exactly as image 2. (Don't forget to shoot several exposures at various levels of defocus and select the one that works best for you.) Afterward, having both images open in software, hold down the shift key as you pull the soft image onto the multiple image file. Adjust the opacity of the out-of-focus layer to taste. This takes some trial and error to get a sense of what works best for you.

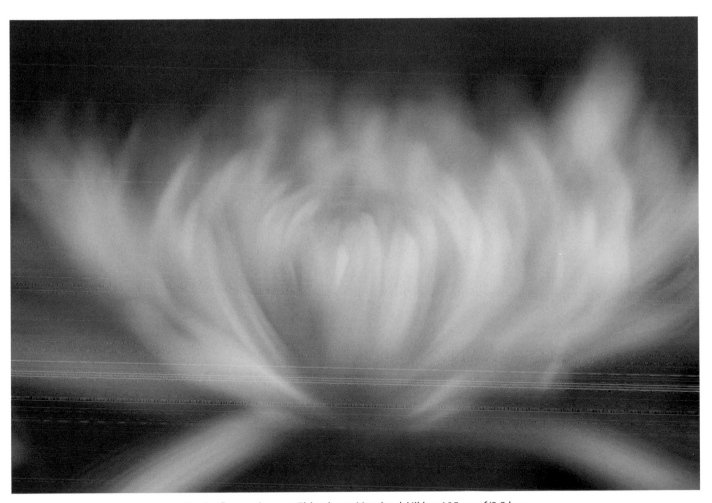

Studio flower abstract, Eldersburg, Maryland; Nikkor 105mm, f/2.8 lens

Technique—Multiple Exposure and Image Overlay

The images above represent tremendous abstract situations. The natural tendency is to find a clean area of trees and pan a long exposure or perform a multiple exposure while moving the camera incrementally in an upward or downward motion. Of course, you can move the camera in any way at all, but normally moving the camera within the orientation of the subject keeps a slight sense of reality in the abstract rendering. In this case, rather than finding an open, unobstructed patch of trees, I chose to use foliage that was in front of the trees as a coloring element. As you can see, the trees are apparent, but the foreground foliage adds a painterly effect, which is enhanced and softened using Nik's Glamour Glow filter. It's easy to disregard a filter or technique based on the name. Glamour Glow seems like it's designed for fashion photography portraiture, but the image shown is also a portrait and this filter adds a soft glow to this natural subject. This filter also works especially well with translucent flowers.

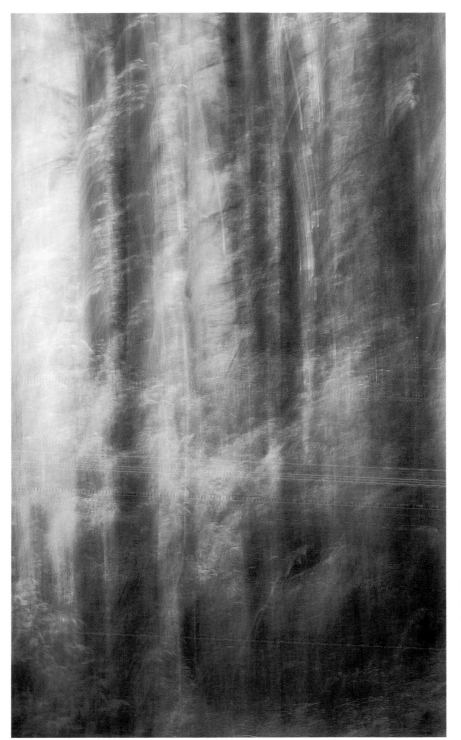

North Georgia;
Nikkor 70–200mm, f/2.8 lens;
2 seconds @ f/22

*Technique—Panning and Nik
Glamour Glow Filter*

As mentioned in the previous image example, this flower was also enhanced with the Nik Glamour Glow filter. The entire image takes on a soft glow and is brightened and slightly more saturated. Compositionally, the shallow depth of field accounts for the soft background, and placing the main subject over the hub of the background leaves creates a visually stimulating frame. Chopping off the top of the flower at the top of the frame is an acceptable way to deal with long subjects.

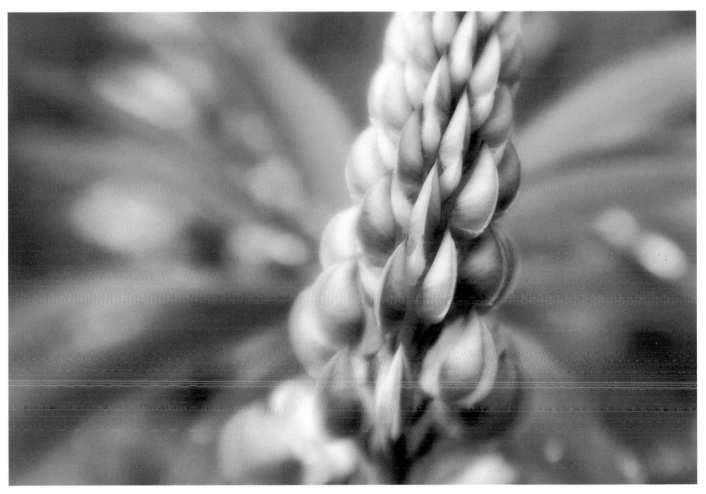

Lupin and leaf, Peggy's Cove, Nova Scotia; Nikkor 105mm, f/2.8 lens; $1/30$ second @ f/8
Technique—Nik Glamour Glow Filter

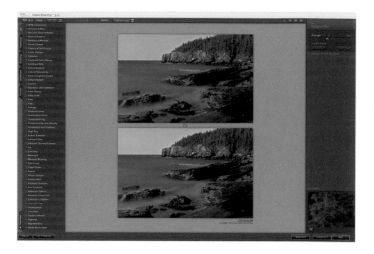

This is a 4-minute exposure made at civil twilight (just enough light to walk around). Since the camera only goes to 30 seconds, the exposure had to be calculated, as I didn't have a handheld meter with me. I found that f/8 gave me a 30-second exposure. The calculation is made by doubling the exposure time at each one-stop increase in f/stop: f/8 = 30 seconds; f/11 = 60 seconds; f/16 = 120 seconds; and f/22 = 240 seconds (4 minutes). With the light changing rapidly at this marginal time of day, I only had time for six long exposures before it got too bright for this effect to work.

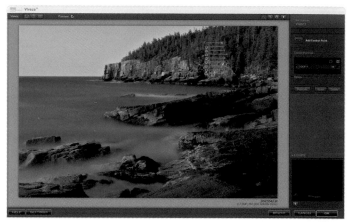

There is a custom menu setting in serious amateur to professional digital cameras that can help reduce noise on long exposures (Long Exposure NR). However, there may be a need for noise-reduction software, such as Nik Software's Dfine 2.0.

In the top frame's image, notice how flat the cliffs are. Using the Skylight filter (bottom image of the first frame) warms the cliffs to replicate dawn's light. You'll also notice that the trees are a bit flat and that there is a large blocked-up shadow area in the rocks.

I used Nik's Viveza Photoshop plug-in to increase the intensity of the greens (middle frame) and to open up the shadow area (bottom frame).

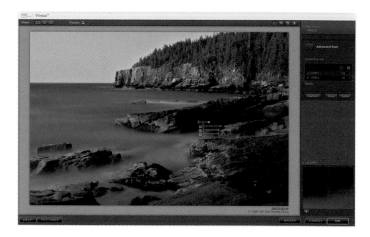

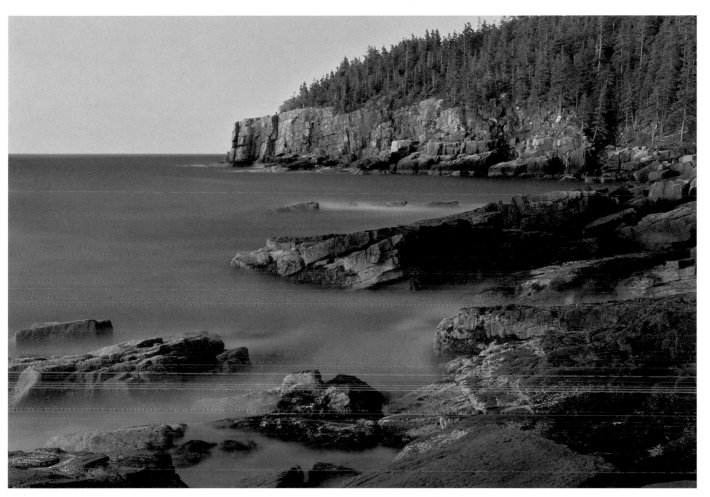

Otter Cliffs, Acadia National Park, Maine; Nikkor 70–200mm, f/2.8 lens; 4 minutes @ f/22

Technique—Nik Skylight Filter and Nik Viveza Photoshop Plug-in

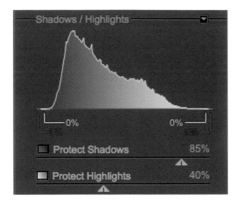

2

1

This classic scene in the Great Smoky Mountains can be reinterpreted in a number of ways. I've been shooting this area for years and I'm always striving for new interpretations by utilizing different lenses, perspectives, filters, and digital enhancements. Using a couple of Nik filters completely altered the feel and mood of this image. Notice in the Midnight basic box (1) that the blur, brightness, and color are all set to 100 percent. The contrast is lowered to help create the softer look. In the Midnight advanced box (2), there are options to protect the highlights so they don't blow out and to protect shadows and control how blocked up they get. I moved these around to get the feel I was looking for, but the greens looked a little flat. I used the Foliage filter (3) to punch up the greens in the grasses and in the canopy.

3

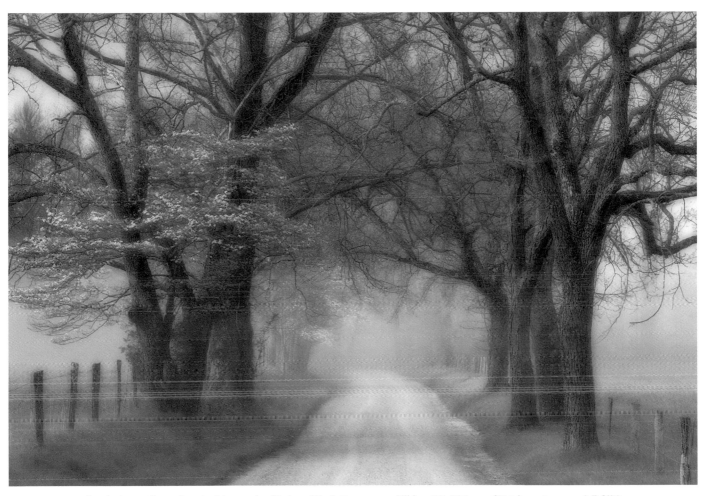

Sparks Lane, Great Smoky Mountains National Park, Tennessee; Nikkor 70–200mm, f/2.8 lens; 1 second @ f/22

Technique—Nik Midnight and Foliage Filters

Polarizing a wide-angle lens will cause an unevenly toned sky. This is particularly true when you are photographing rainbows. As I polarize for the greatest color saturation in the rainbow, color may be strong in one part yet correspondingly weak in another. In this case, I noticed that as I turned the filter the vivid color was in the right third, then the middle third, then the left third. I needed to shoot three exposures to solve this problem, focusing the greatest color saturation on different parts of the rainbow in each of the three exposures to keep the color uniform across the whole arc. This image was shot as an in-camera triple exposure. It could also be created using three separate exposures, then assembling the images in software by dragging two files onto the third by holding the shift key for exact registration. Adjusting the opacities (layer 1 opacity = 100 percent; layer 2 opacity = 50 percent; layer 3 opacity = 33 percent) will recreate the in-camera look with no discernable difference in the final result.

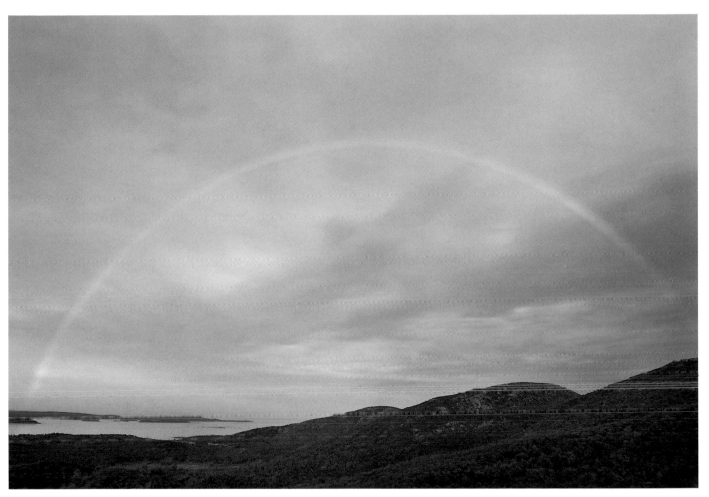

Spring rainbow, Acadia National Park, Maine; Nikkor 12–24mm, f/2.8 lens

Technique—Triple Exposure

I'm looking for the unexpected. I'm looking for things I've never seen before.
—Robert Maplethorpe

Polarizing filters and neutral density filters cannot be replicated digitally, yet both are essential. The artificial intelligence doesn't yet exist to create a true polarizing filter. How will it know when to darken a blue sky or when to remove glare from leaves? And a neutral density filter is needed to capture smooth water via long exposures—this effect cannot be recreated digitally.

This image was shot in late morning on a sunny fall day. The longest exposure of ISO100 at f/22 only rendered a half-second exposure, which did not smooth the water enough for what I wanted. After adding the Singh-Ray Vari-ND filter, I was able to dial in five stops of neutral density rendering a very long and colorful 15-second exposure. Compositionally, I separated the pier pilings as much as possible in the very busy scene.

Pier graveyard, Chesapeake City, Maryland; Nikkor 35–70mm, f/2.8 lens; 15 seconds @ f/22
Technique—Singh-Ray Vari-ND Filter

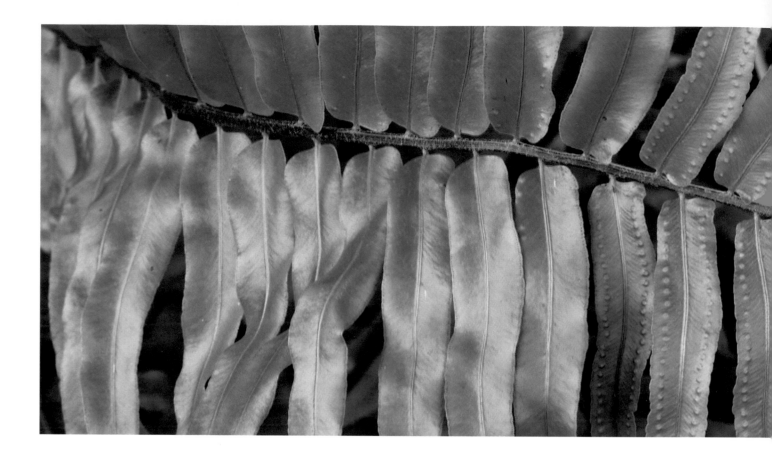

This image is a stitch of five exposures using the Photomerge command in Photoshop CS3. For those reluctant to use Photomerge based on having used Photoshop CS2, rest easy, as this greatly improved version of Photomerge is fast, powerful, and accurate. It's a good practice to photograph in vertical format, overlapping each image 25 to 50 percent so that the software can find the edges of the images when merging. Shooting in vertical format also enables cropping without dramatically thinning the image, as is the case when stitching horizontal images. Rather than polarizing to cut down on the glare, I chose to leave it alone as the glare adds texture to the leaves. I used a curve adjustment to darken the image to taste. In order to keep the camera level while creating this close-up pan, I used the Really Right Stuff panning head.

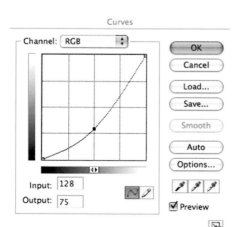

Brookside Gardens, Wheaton, Maryland; Nikkor 80–200mm, f/2.8 lens; Canon 500D filter; $1/2$ second @ f/22

Technique—Photomerge and Curve Adjustment

This image is a good example of an image overlay, which can be done in-camera using higher-end Nikon camera bodies. The opacity of each image can be adjusted to favor the sharp exposure or the soft exposure. In this case, the soft effect was slightly brought out by lowering the opacity of the sharp image, allowing for the soft glow to shine through. This effect can also be performed in software by shooting two images, one normal and the second wide open and defocused. Drag one image onto the other in software (holding down the shift key for precise registration), then adjust the opacity of the soft image to taste.

In order to blur the hard edges of the leaves and stem, I used the Singh-Ray Tony Sweet Soft-Ray filter on the defocused image to further soften the hard edges. This addition was largely responsible for the glow of this image.

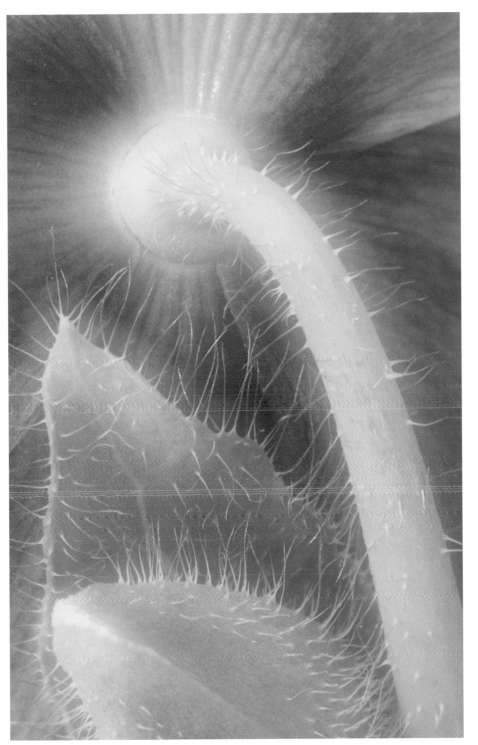

African blue poppy,
Philadelphia, Pennsylvania;
Nikkor 200mm, f/2.8 macro
lens; 4 seconds @ f/22

*Technique—Image Overlay
with Singh-Ray Tony Sweet
Soft-Ray Filter*

Digital art software has empowered both the painterly side of photographers, and the photographer side of painters.

—Buffy Sainte-Marie

A quick and easy way to replicate a different artistic medium for your images is by using Alien Skin's Snap Art software. There are a number of different media that can be replicated in the drop-down menu, such as oil paint, comic illustration, and watercolor. This single tree with the warm foreground and cool background image was chosen because I imagined it as a watercolor painting. However, none of the default settings worked. I changed the paint coverage to 100 percent to fill the canvas, took the fine edge detail to zero for a broader, less detailed look, then I lowered the brush size to taste. After all this, the saturation still wasn't quite right, so adding a Hue/Saturation adjustment layer was needed to finalize the fine art look.

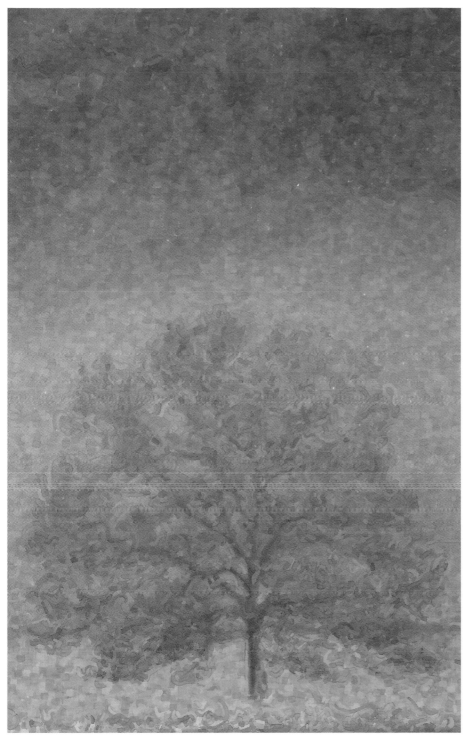

Great Smoky Mountains
National Park, Tennessee;
Nikkor 70–200mm, f/2.8 lens;
$1/2$ second @ f/22

Technique—Alien Skin's Snap
Art Software: Watercolor

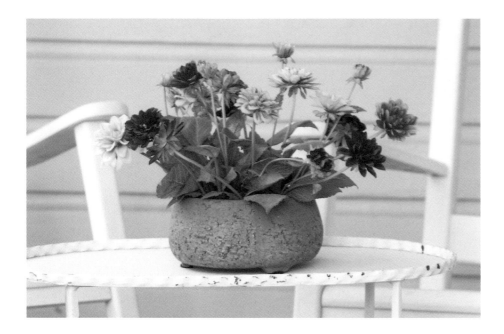

This is what I would call a Nik "tour de force." I previsualized this subject as a Hallmark card–style image. As you can see from the small insert "before" image, I had a lot of work to do to get to the previsualized larger image. To the right, you see the Photoshop layers palette with one Photoshop adjustment layer and five Nik filters applied. The filters were applied starting from the bottom background layer and finishing with the top foliage layer. The Nik Pro Contrast filter added color punch and contrast globally. The Nik Sunshine filter was painted in over the flowers for added warmth. The Nik Vignette Blur filter was used to soften the edges of the image space. I applied Nik's Darken/Lighten Center filter globally using the default setting to slightly lighten the center. Both of the aforementioned filters were applied in order to pull the viewer into the center of the image. Then a curve adjustment layer was added in Photoshop to slightly increase the saturation globally. Then Nik's Foliage filter, which only affects greens, was painted in to brighten them.

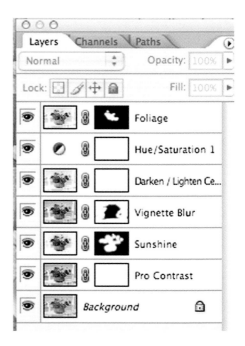

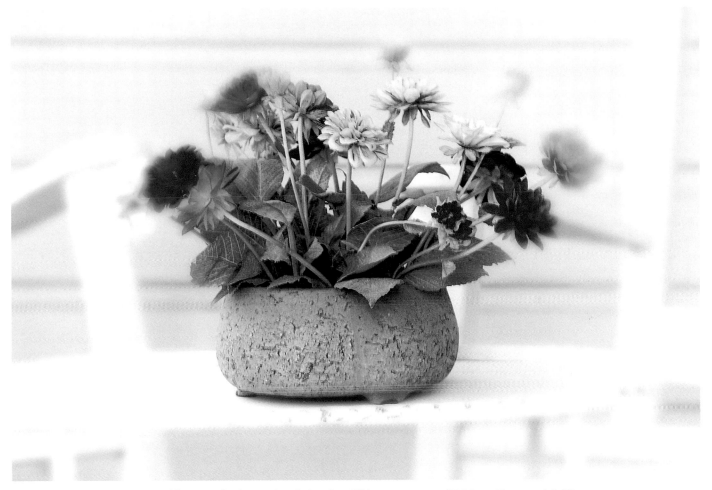

Potted flowers, Charleston, South Carolina; Nikkor 70–200mm, f/2.8 lens; ¼ second @ f/8

Technique—Nik Pro Contrast, Sunshine, Vignette Blur, Darken/Lighten Center, and Foliage Filters

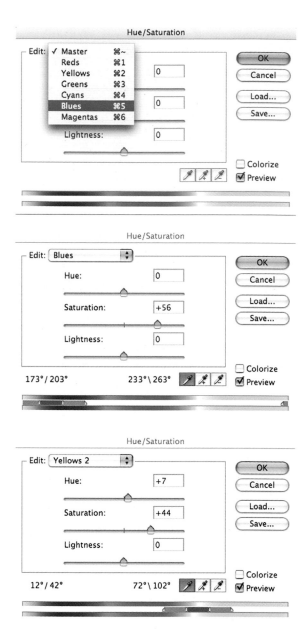

Using curve adjustment layers is critical in image processing and is a way to see image adjustments without degrading the image if you're shooting in RAW (which is highly recommended). The effects don't take effect until the image is flattened. This image is a classic Great Smoky Mountains image made in early spring. In this great situation, there is a crisp low-lying fog with a clear blue sky and green grass. Two curve adjustment layers were used to enhance the color of the blue and green tonalities. In the Hue/Saturation box at the top, next to Edit, is a drop-down color menu. I selected Blues and used the mid-tone eyedropper (highlighted by default) to sample the blue sky at the top center of the frame. Then I moved the saturation slider to the right until I increased the saturation to my satisfaction. After selecting Greens in the drop-down box, I clicked on the green at the bottom/center of the frame with the mid-tone eyedropper and moved the slider to increase the saturation. I then slightly increased the hue to brighten the color a bit.

Note: Even though I clicked on Greens, Photoshop interpreted the color as Yellows 2. This accounts for the warming of the fog.

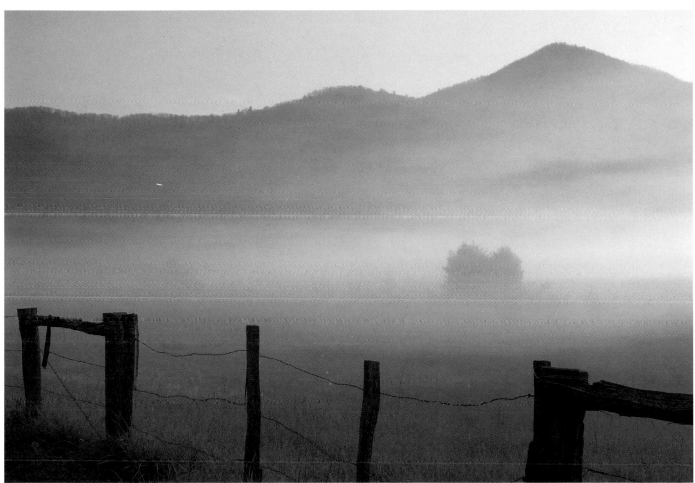

Misty morning, Great Smoky Mountains, Tennessee; Nikkor 12–24mm, f/2.8 lens; 2 seconds @ f/22

Technique—Curve Adjustment Layers

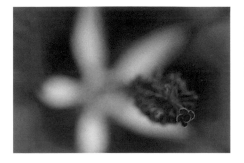 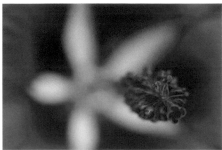 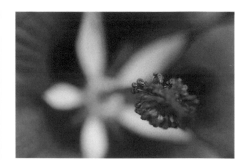

Helicon Focus is a pretty amazing piece of software. In this particular image, it allowed me to shoot wide open but sharpen a particular section of the image without affecting the background—in this case, the stamen of a hibiscus. Because of the length of the stamen on this flower (and similar flowers), stopping down to get the stamen sharp will also bring in the background petals. On this image, I wanted to get the stamen completely sharp while maintaining the soft red background. I shot eight exposures, focusing very slightly more inward on each exposure. You can get a sense of what I mean by seeing the different focus points in the three images above, which are the first, fourth, and eighth exposures in the sequence. Then I opened Helicon Focus, directed the software to the folder where all of

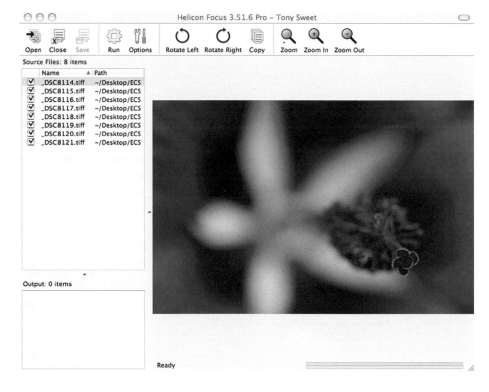

the images were and selected Open. After making sure that all of the images were in the box (above), I clicked Run. The resulting compilation of the images is shown on the opposite page. As you can see, the stamen is razor sharp, and the background remains soft, as if shot wide open.

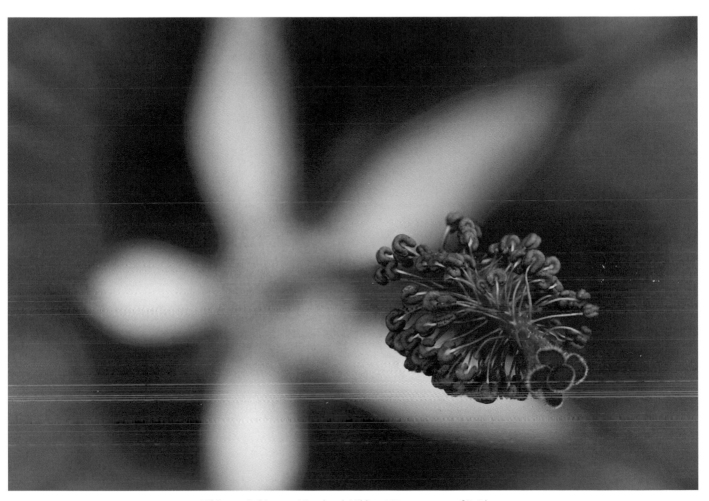

Hibiscus, Baltimore, Maryland; Nikkor 105mm macro, f/2.8 lens

Technique—Helicon Focus

This is an extreme close-up of a tulip center. Even at f/32, getting both the tips of the petals and the entire stamen sharp is impossible. I used Helicon Focus earlier to selectively sharpen the stamen of a hibiscus while leaving the background soft. That image required nine separate exposures to bring the selected area into focus. I wanted to ensure that the petals framing the stamen and the entire stamen itself were razor sharp, so I went a bit over the top here shooting thirty-two exposures at f/16, beginning at the very tip of the petals and very slightly progressing farther into the scene until I focused as far back as the scene went (diagram 1).

After evaluating the scene, the sharpness was just a bit distracting—it pulled the eye all over the frame. All I wanted was to highlight the petals framing the pristine bright yellow stamen.

In diagram 2, you can see that using Nik's Color Efex 3.0 Vignette Blur tool softened the edges of the frame, directing the viewer to the sharp petals and stamen.

1

2

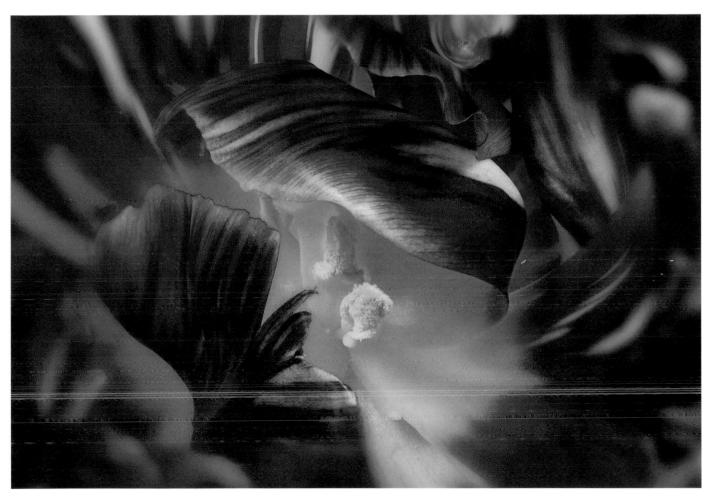

Tulip, Eldersburg, Maryland; Nikkor 105mm, f/2.8 lens
Technique—Helicon Focus and Nik Vignette Blur Filter

Here's another situation where Helicon Focus worked very well. In this image there are purple foreground flowers and yellow background flowers. Wanting them to be as soft as possible, I had to use the widest aperture on my 105mm macro lens. The high magnification and inherent shallow depth of field of this lens at its widest aperture made it impossible to get the entire stamen sharp in one exposure without revealing more detail in the soft foreground and background colors. This is a classic situation for using Helicon Focus. I wanted the entire stamen sharp and everything else remaining as shot, keeping the completely blown-out background/foreground tonalities. You can see in the small five-image series on the opposite page the successive focus points of each exposure, and the Helicon box (above right) shows where the blending of all exposures took place.

The lasso tool was used to select the stamen with a feathering of 40 pixels. A little extra saturation was added to the stamen using a saturation curve adjustment layer and increasing saturation to 20. This was done to draw the viewer's attention to the stamen.

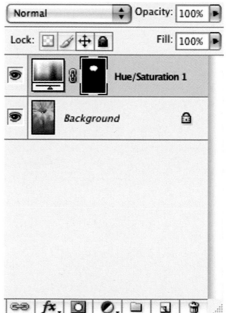

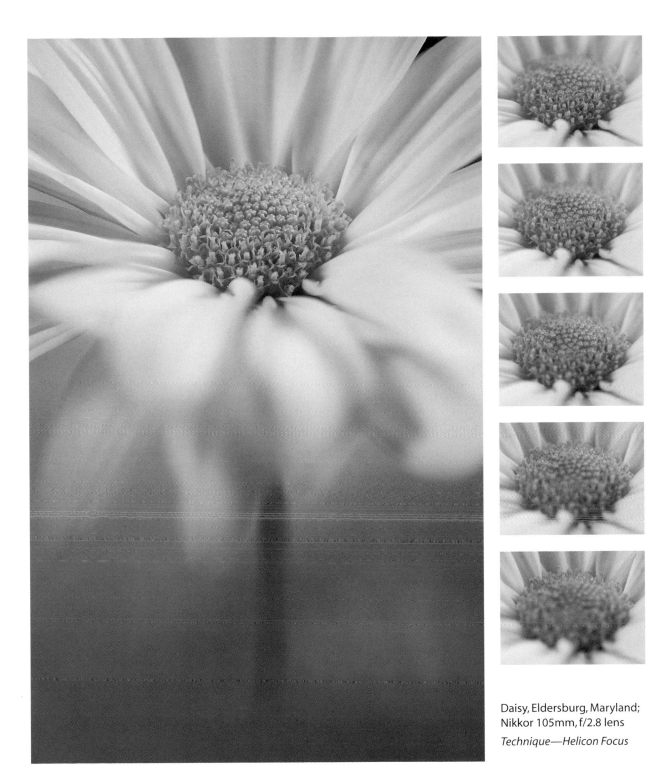

Daisy, Eldersburg, Maryland;
Nikkor 105mm, f/2.8 lens

Technique—Helicon Focus

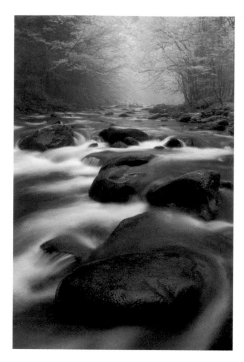
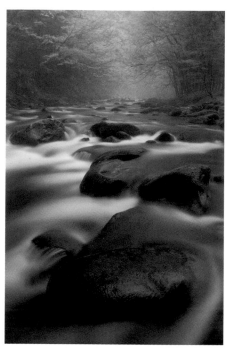

The longest exposure attainable using in-camera metering on most digital cameras is 30 seconds. Many digital cameras, even some professional-level cameras, have ISO200 as their lowest possible ISO. The lowest ISOs are where the highest quality imagery is made. They're the most grain-free ISOs and the color and contrast are the best for printmaking and for high-end publication.

There are two specific issues to discuss here. The first is how to achieve a much longer exposure time in bright conditions. You'll notice the great difference in the smoothness of the water between the 8-second at f/22 exposure and a 30-second exposure using the Singh-Ray Vari-ND filter. You cannot achieve this effect artificially. An ND filter is the only way to achieve longer exposures. The problem with a regular ND filter is that it can be dark to look through, which is especially an issue when shooting in low light. In this final image, I added two full stops beyond what the camera could meter by dialing in two extra stops using the Singh-Ray Vari-ND, giving me a 30-second exposure. The difference between the 8-second exposure and the 30-second exposure is apparent. The second issue is that there is a slight warm cast when dialing in neutral density using the Vari-ND. This can be adjusted using the White Neutralizer filter in Color Efex 3.0. Notice the filters box at the bottom of the page. The default setting removed the amber cast, especially noticeable in the white wash of the mountain stream.

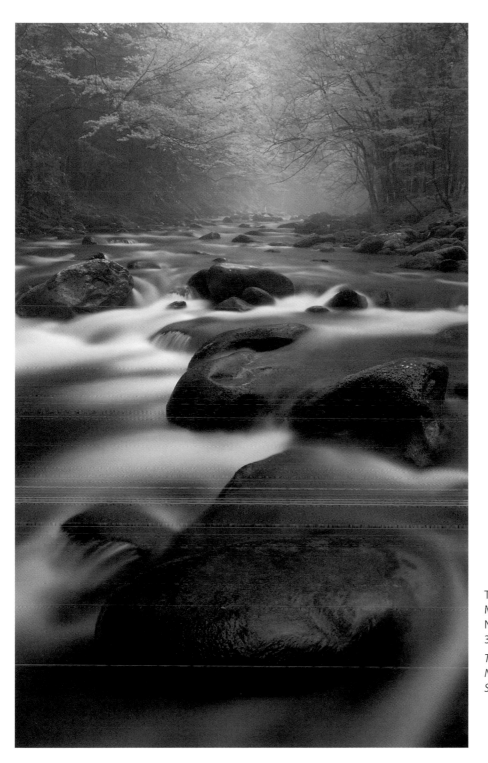

Tremont, Great Smoky
Mountains, Tennessee;
Nikkor 12–24mm, f/2.8 lens;
30 seconds @ f/22

*Technique—Nik White
Neutralizer Filter and
Singh-Ray Vari-ND Filter*

This image was made late in the day during a light snow. The flat blue light is always an issue in these types of situations. You can try to counteract the blue cast with a warming filter effect. This can be done many ways. You can warm (add amber to) a scene by using a glass 81 series filter. Because we can replicate the warming effect in software, using a Photoshop filter would work. Nik Software's Brilliance/Warmth is an excellent warming filter with more controls. But in this case, any warming looked artificial. I chose to alter this scene, adding more density, contrast, and softness using Nik Software's Midnight filter. The soft, grainy effect gave this image a "grunge" look.

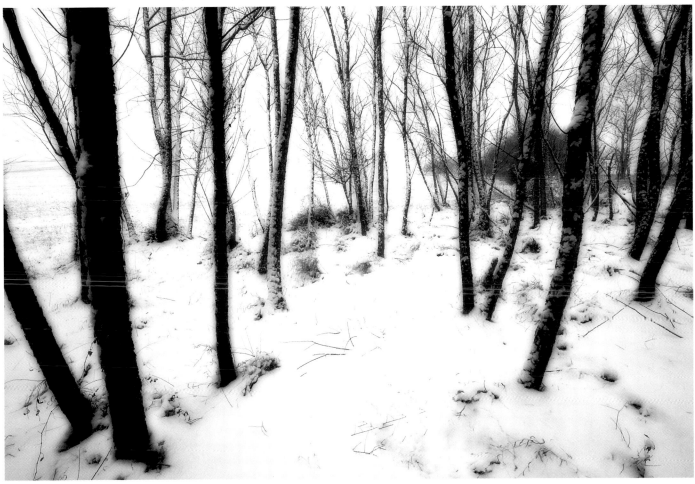

Winter tree pattern, Eldersburg, Maryland; Nikkor 14–24mm, f/2.8 lens; ¹/₄ second @ f/22

Technique—Nik Midnight Filter

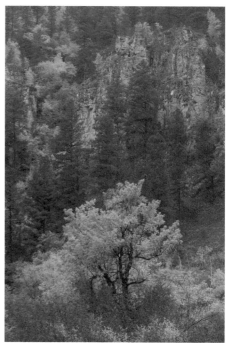

Coming from the Velvia ISO50 school of nature/outdoor photography, my goal with traditional scenic images is to replicate the pop and vivid color of a Velvia slide. There are several applications and Photoshop plug-ins that will simplify getting to the Velvia look without lengthy Photoshop experimentation. Alien Skin's Exposure 2 is a useful film emulation plug-in. The folks at Alien Skin actually shot real film and created a curve based on the RGB values. When selecting the film in the dialogue box shown above, a separate layer is created. The effect is applied to the maximum degree when selected. The opacity can be lowered, if the effect is too strong. As you can see, the opacity is set to 80 percent.

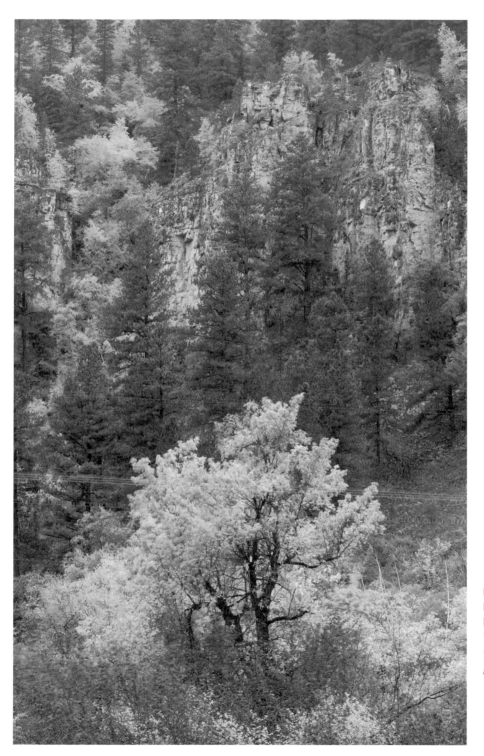

Fall color, Black Hills
National Park, South Dakota;
Nikkor 70–200mm, f/2.8 lens;
$1/2$ second @ f/22

*Technique—Alien Skin's
Exposure 2*

This is not exactly a nature image, although it's shot just outside of the Great Sand Dunes and the Sangre Del Cristo Mountains in south-central Colorado. However, it's a perfect candidate to illustrate Nik Software's Graduated ND filter. The original image seemed a bit flat in the late morning light and needed some help. By controlling how far the ND comes down from the top of the frame and blending how the grad effect tapers off, I was able to darken the sky and leave the crop lines untouched. Then, by being able to adjust the lower portion only, I was able to lighten the green crop lines. I felt that the image still needed a bit more contrast, so I performed a curve adjustment layer. Selecting the medium contrast preset in Photoshop CS3 rendered the desired look in the final image on the right page.

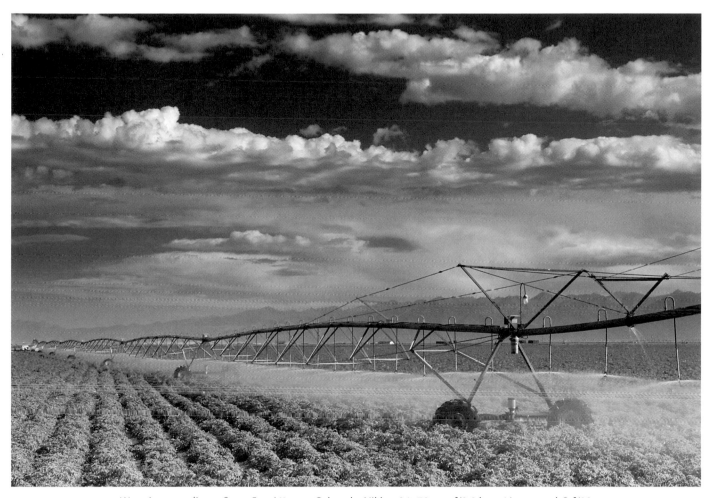

Watering crop lines, Great Sand Dunes, Colorado; Nikkor 24–70mm, f/2.8 lens; $1/60$ second @ f/22

Technique—Nik Graduated ND Filter

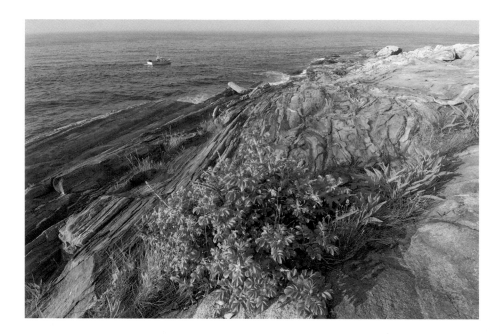

This very cool look from the transparency days was referred to as a slide sandwich or montage. Created very simply, I took two different exposures and placed two pieces of film in a slide mount, creating a surreal image. It's been the quest of many of us to find a way to replicate the effect digitally. The following method comes pretty close.

In the layers palette, duplicate the layer to create a background copy layer. On the background copy layer, go to Image>Apply Image, then set the blending to screen Duplicate the Background Copy layer, creating a background copy 2 layer. Go to Filter>Blur>Gaussian and set to 20 (set to between 15 when there is detail and 50 +/− for less detailed subjects), then select multiply in the layers drop-down menu.

Be careful to avoid subjects with dark shadow areas, as the shadows will get much darker and slightly larger in this process, as you can see in the rocks along the shoreline and within the foliage.

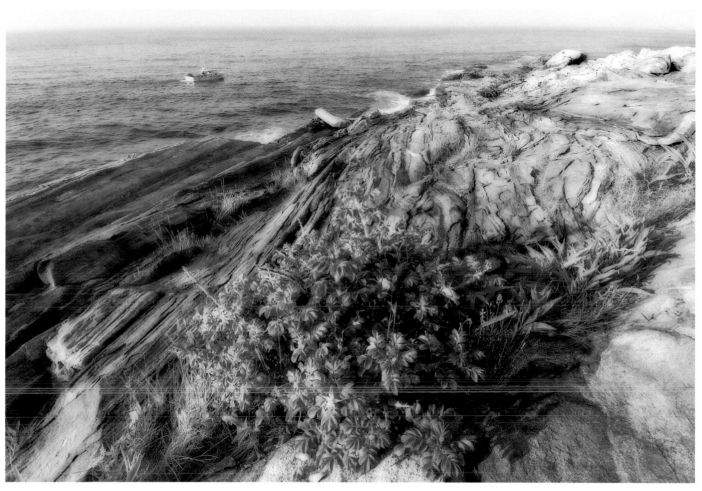

Rock formations, rugosa, and lobster boat, Pemaquid Point, Maine; Nikkor 24–70mm, f/2.8 lens; 1/4 second @ f/22

Technique—Digital Sandwich in Photoshop

Many photographers have the Singh-Ray Gold-N-Blue polarizer and may have noticed a dramatic shift when using it on their digital cameras. As you can see in the first example image, the Gold-N-Blue polarizer has a heavy rose color cast with the white balance set according to the bright sun. Using color adjustments in software, I was unable to find a quick solution to this problem. I prefer not to spend a lot of time correcting images in software, so, like other photographers, I decided to put the filter away and chalk it up as a casualty of the digital revolution. Then, in a conversation with Dr. Bob Singh, the color cast issue came up. Dr. Singh asked if I had tried to set the Kelvin temperature quite a bit to the blue range, 3200K. This is done by customizing the white balance using the white balance temperature slider in RAW processing software. I found that 3200K to 4200K works to bring an image back to the Gold-N-Blue polarizer range that worked so well in the film days.

In the images to the right, both made with the Gold-N-Blue polarizer, the first was set to bright sun white balance, while the second, set to 3600K in software, replicated the true effect of the filter.

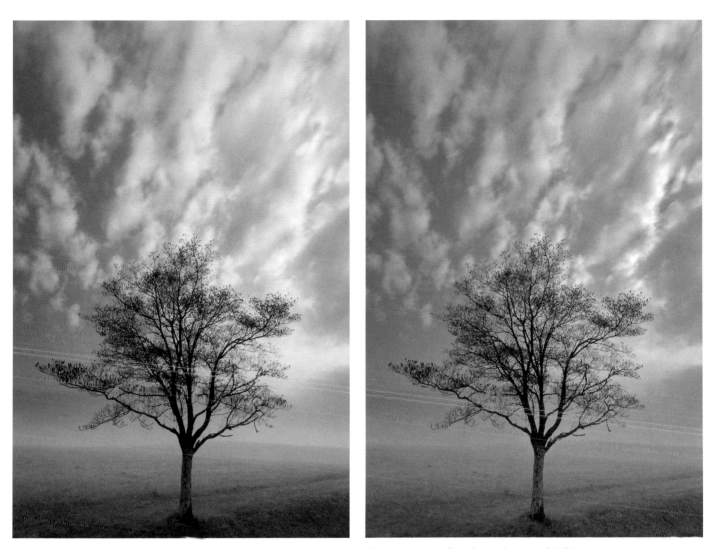

Lone tree, Great Smoky Mountains, Tennesse; Nikkor 24–70mm, f/2.8 lens; $1/2$ second @ f/22

Technique—Singh-Ray Gold-N-Blue Polarizer with Kelvin Adjustment

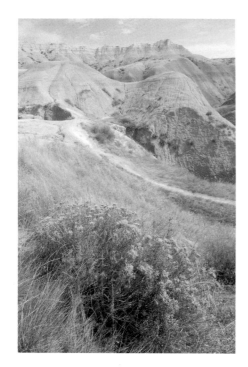

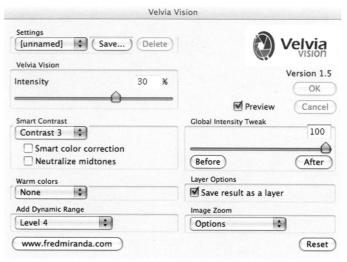

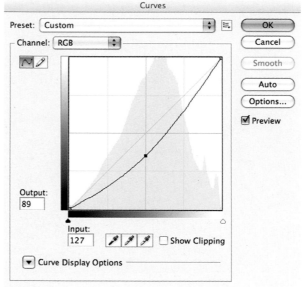

As we all know, there are numerous ways to achieve the same desired effect in software (e.g., Photoshop). Coming from the "old days" of Fuji Velvia 50 transparency film, I try to achieve that look in the digital world. Velvia Vision by Fred Miranda is a quick, easy, and manageable way to achieve the Velvia look. As you can see from the Velvia Vision filter control panel, you can adjust contrast, warmth, and dynamic range. On this image, the warmth is set to "none" because the scene is very warm already. The intensity is not at 100 percent, and seldom is because the effect is too strong. Various settings can be saved for future use. The image was a bit too bright, so I added a curves adjustment layer to darken the scene slightly.

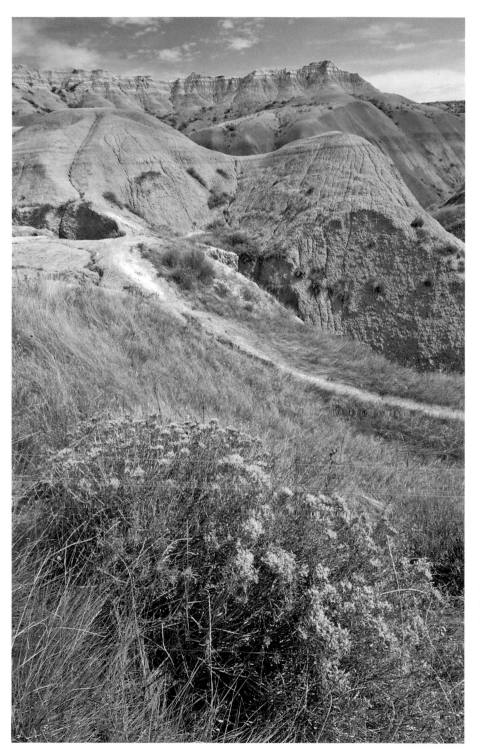

Midday scenic, Badlands National Park, South Dakota; Nikkor 24–70mm, f/2.8 lens; 1/4 second @ f/22

Technique—Velvia Vision

Digital infrared is a great—and fun—format. Although many programs can turn the greens and reds to white, photographic software in general lacks the glow of pure infrared and the results can be inconsistent. Besides, there's more to infrared imaging than turning greens to white. If you happen to have an old digital camera or want to convert a new camera to a dedicated infrared camera, there are companies that will convert your camera for you (see the glossary). If you submit work to stock agencies, a 50MB file is required, which will necessitate having a converted camera in the 10.4MP range. The files are recorded in RGB and will appear colored as in the small image.

In your chosen RAW processing software, decrease the saturation to zero, and dramatically increase contrast to taste. If the line in your histogram is at the right edge or climbing up the right side, decrease exposure or use the recovery slider, as in Aperture, Lightroom, and Adobe Camera Raw, until the line is just short of the right edge of the histogram. Evenly lit, bright, sunny scenes with white puffy clouds are the best-case scenarios for infrared photography.

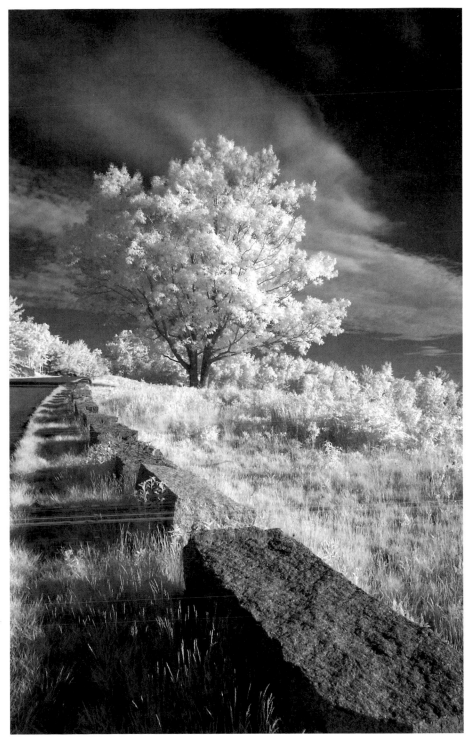

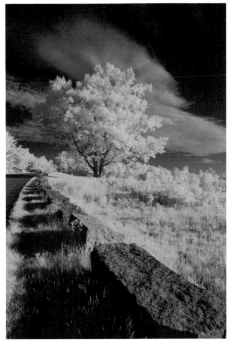

Acadia National Park, Maine;
Nikkor 12–24mm, f/2.8 lens;
$1/_{125}$ second @ f/22

*Technique—Converted
Infrared Camera*

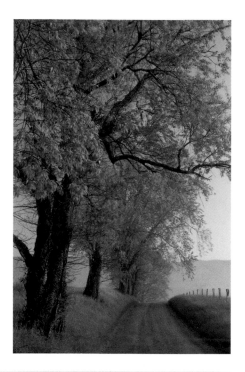

Digital infrared is a lot of fun and can give the most banal scene a whole new and transformational look. Such software as Nik Software and Alien Skin Exposure 2 are excellent for converting an already created image to infrared. However, it's important to note that there is more to infrared than just changing greens and reds to white. On a scene that is mostly green or red, software can do an excellent job replicating true infrared; however, where the tonalities are less obvious, the software can't "see" the tonality to change to infrared. The difference is apparent between the next example, which is a software conversion to infrared using Alien Skin Exposure 2, and the examples on pages 62 and 63, where software alone was not adequate.

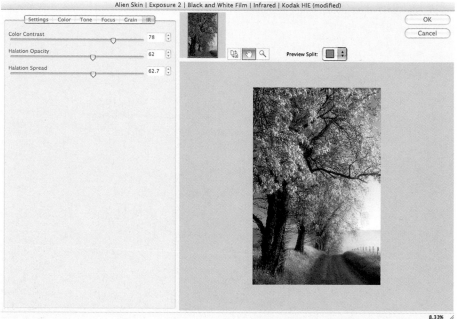

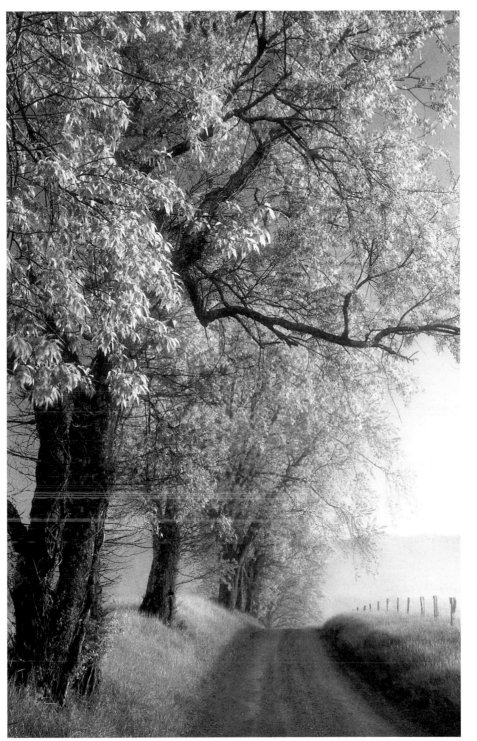

Hyatt Lane, Great Smoky
Mountains, Tennessee;
Nikkor 17–35mm, f/2.8 lens;
1/4 second @ f/22

*Technique—Alien Skin
Exposure 2*

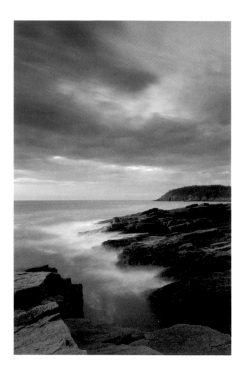 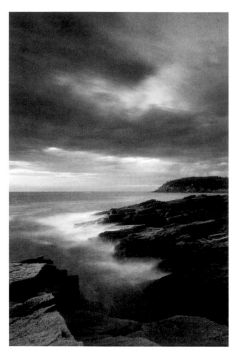

This illustration reveals a limitation of software-based infrared conversions. The middle image is the best attempt using software to create an infrared image from the original. Notice that the dark kelp is not read by the software as infrared and appears as black and white. However, the grain is more in keeping with infrared film, which is desirable. The main image on the opposite page is shot with an infrared-converted Nikon D200. The very dark green kelp now shows up readily in this pure infrared image, as do the distant trees on Otter Cliffs.

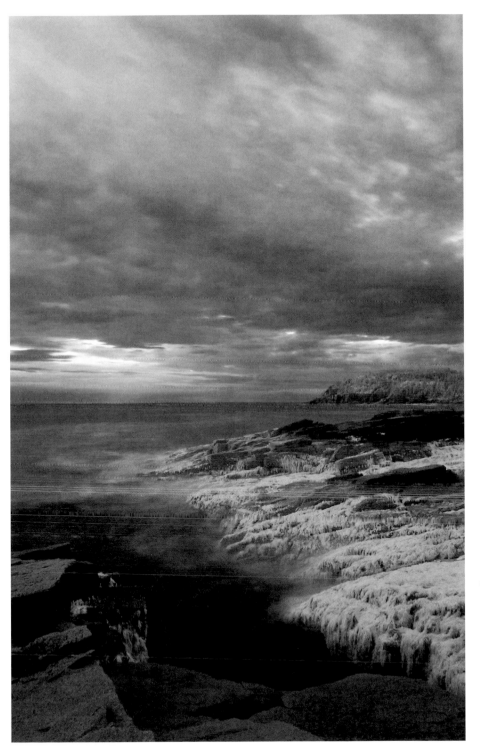

Thunder Hole,
Acadia National Park, Maine;
Nikkor 24–70mm, f/2.8 lens;
1 second @ f/22

This overlay effect is a fun thing to do and can be done a number of ways, like converting the color image to infrared in Nik Color Efex. Since I use an infrared-converted D200 for pure infrared, this sequence is created using two D200s. For those without infrared-converted cameras, this effect can also be achieved by converting a copy of the color image to infrared using the Nik Color Efex Infrared Film filter. The first image is shot in color. It's very important to take note of the exact (or as close as possible) placement of the first camera, then place the second camera (infrared) in the same location on the tripod camera mounting plate. After processing both files, have both files open in Photoshop and hold down the shift key when dragging the infrared onto the color image in order to get the images to register. Since the opacity is 100 percent on both images, when you drag the infrared onto the colored image, the infrared image will completely obscure the color image. Adjust the opacity of the infrared image until the desired amount of red emerges. After seeing both images, the register will most likely be a bit off. You'll need to nudge the top image around using the arrow keys to get both images as close as possible. You can then crop off the uneven edges.

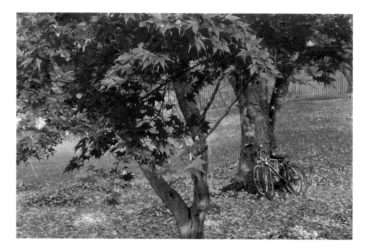

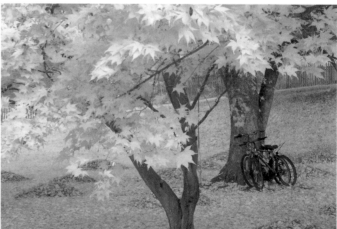

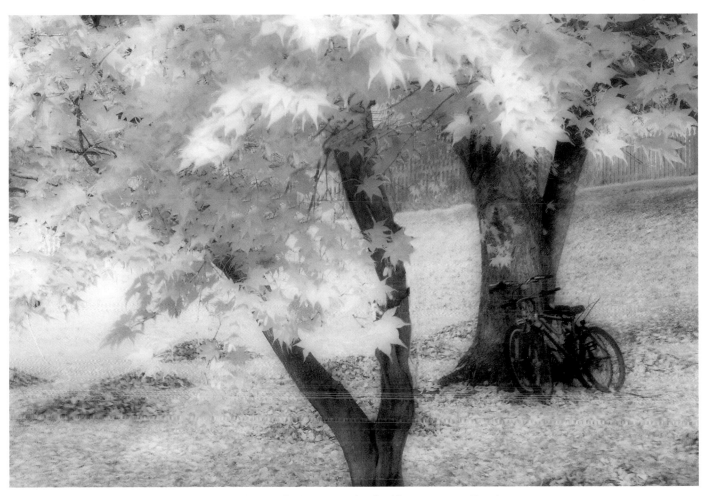

Backyard scene, Eldersburg, Maryland; Nikkor 24–70mm, f/2.8 lens

Technique—Infrared and Color Images Combined

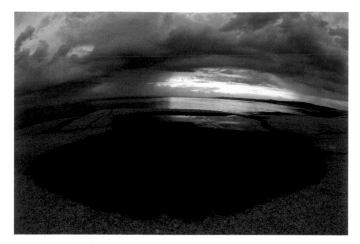

1

This sequence illustrates the use of curve adjustment layers. Image 1 is the original. As you can see, the sky and clouds have good color, texture, mood, and detail, but the tidal pool and foreground are a bit dark.

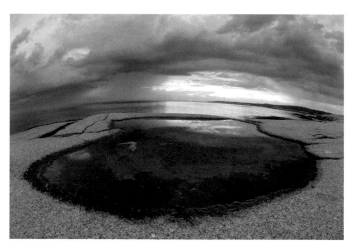

2

Image 2 illustrates the use of a curve adjustment layer to lighten the foreground rocks. The selection of the rock foreground and tidal pool is shown in the layers box. This is a large selection and necessitated a large (100-pixel) feather number. You can see the amount of adjustment in the Curves box, which will, of course, vary depending on your subject. In image 3, the tidal pool is still too dark. Using the lasso tool to select the tidal pool, I created another curve adjustment layer to brighten the tidal pool area without affecting the already brightened rock foreground. You can see that there is some color apparent in the tidal pool. Then, I selected the tidal pool again and, in the Hue/Saturation box, I increased the master saturation to bring out the blue/grey and green (lichen) tonalities in the pool. Notice the dramatic difference between the opening image (1) and the final image.

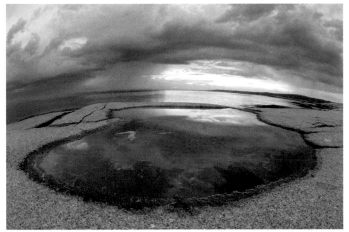

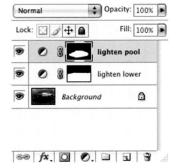

3

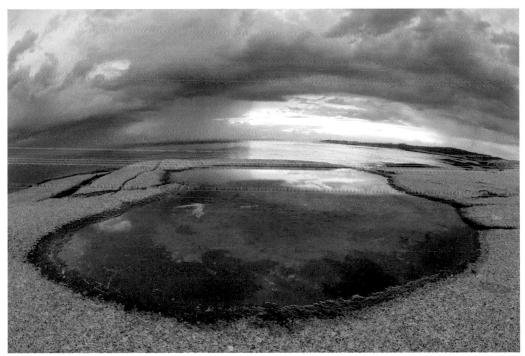

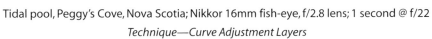

Tidal pool, Peggy's Cove, Nova Scotia; Nikkor 16mm fish-eye, f/2.8 lens; 1 second @ f/22

Technique—Curve Adjustment Layers

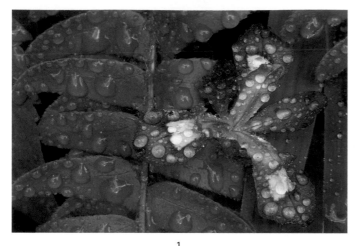

1

2

3

4

5

Here's a pretty cool technique created by Betterphoto instructor and author Richard Lynch. It really caught my attention because it's specifically designed to soften highlights. Here's what you do:

1. Open an image (diagrams 1 and 2).
2. Click on the channels tab (diagram 3), then hold down command (Mac) or control (PC) and click on the RGB channel thumbnail (picture icon). You'll see marching ants around the selected highlight area.
3. Copy and paste, then return to the layers tab. You'll see a new layer created containing the highlights only (diagram 4).
4. Make sure the new layer is highlighted and select Filter>Blur>Gaussian Blur (diagram 5). Notice my selection is 30 pixels. The number should reflect what you think looks good. You can also adjust the opacity if the effect is a bit strong.
5. And since the soft effect lowers contrast, duplicate the layer you were just working on and select soft light from the blending drop-down menu (diagram 6).

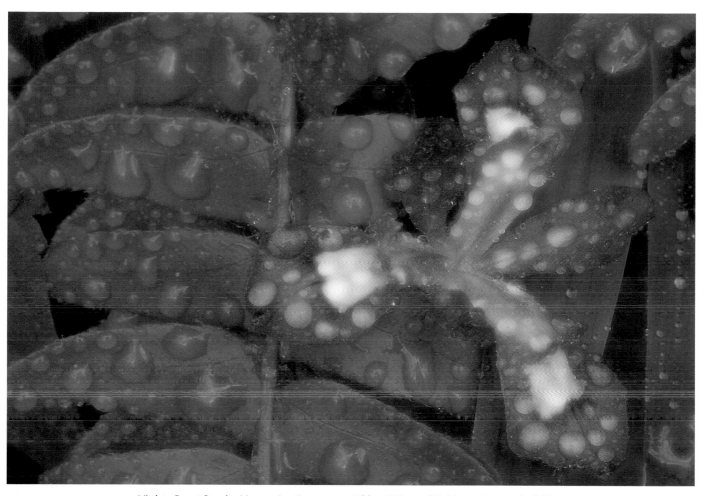

Violet, Great Smoky Mountains, Tennessee; Nikkor 105mm, f/2.8 lens; 4 seconds @ f/22

Technique—Soften Highlights in Photoshop

The hardest thing in photography is to create a simple image.

—Anne Geddes

Here's a quick way to get a soft, surreal look: use a couple of Nik filters with lighter-toned, more translucent subjects.

Box 1 is divided in half with before and after images. The left side is the original image and the right side features the result of using the Film Effects filter, which simulates different film types. I chose the Fujichrome Velvia 100 filter and kept the default settings.

In box 2, the process continues with the Velvia conversion on the left and the Classical Soft Focus filtered image on the right. Notice the settings are maxed out to 100 percent with no shadow or highlight protection to let the image blow out the highlights, adding to the diffused glow of this image.

On the opposite page, you see the original image and the main image after the two Nik filter conversions.

1

2

Fern group, Baltimore Conservancy, Maryland; Nikkor 70–200mm, f/2.8 lens; 1 second @ f/22

Technique—Nik Film Effects and Classical Soft Focus Filters

Great art picks up where nature ends.
 —Marc Cahgall

This image was created in-camera with the Nikon system multiple exposure custom setting. Using autofocus, I rotated around the one relatively sharp flower. I zoomed in slightly and twisted the camera between each exposure. The sequence is as follows: autofocus on the flower center; take the picture; zoom in very slightly; twist the camera to the right; repeat the sequence ten times. The technique is pretty straightforward. It is critical to find a viable subject area and have a previsualized sense of what color combinations work. This sense is gained through experimentation and shooting a great deal of multiple exposures, analyzing the effects afterward, and readjusting. These images tend to come out a bit flat because of all the movement and multiple layers of images. In Aperture, I went to the color tab, increased saturation in the greens, and lowered luminance in the yellows to tone down the highlights. I also slightly increased contrast. Finally, I used the select retouch tool in Aperture to clone out the dust specks. I adjusted everything in Aperture, completely circumventing Photoshop for a faster and more efficient workflow.

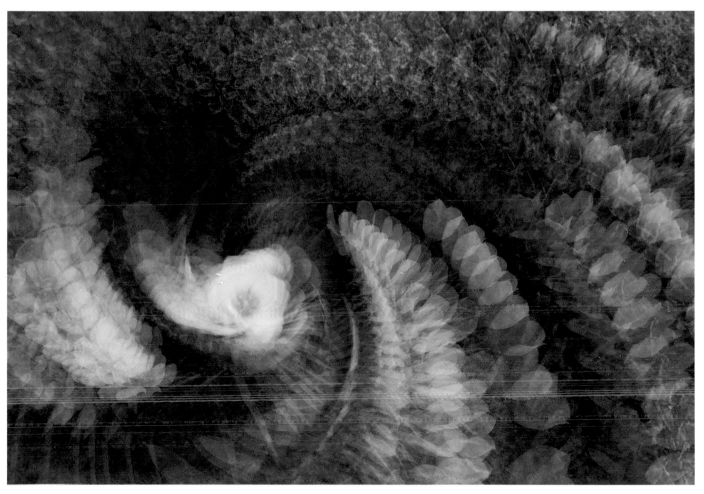

Flower zoom/swirl multiple exposures, Kennett Square, Pennsylvania; Nikkor 24–70mm, f/2.8 lens; f/22

Technique—Multiple Exposures

Taking multiple exposures is a great technique, especially to create artistic interpretations of your subject. Many of the older film cameras had the capability to create many exposures on a single piece of film; however, only a few digital cameras have that option. Pro-level Nikon cameras can create in-camera multiples quite easily, but your camera may not be capable of performing in-camera multiple exposures. I was made aware of a cool technique to replicate the look of creating images in-camera by my friend, great photographer, and Photoshop guru Ellen Anon. It's actually quite simple and fast to execute. We'll shoot ten exposures for this example. Here's what you do:

1. Shoot ten images, moving the camera slightly between exposures, creating ten separate files.
2. Open all ten images in Photoshop or any editing program that has layers (shown in above image).
3. Select one image as your prime image upon which you'll drag all other files. This can be done in random order. Sequence is not important.
4. Click on an image to make it active; then, holding down the shift key to perfectly align the image, click and drag onto your prime image. It will read, "Layer 1." Change it to read "Layer 2." That way the remainder of the layers will continue from Layer 3 to Layer 10. (There is a practical reason for this, which we will get to a bit later.) Close the image you just dragged over.
5. Repeat the process for the remainder of the images, and you should see the layers as in diagram 1.
6. *This is critical*: Change the opacity to 1 over the layer number. (For example, background is Layer 1 and the opacity is $1/1 = 100$ percent; Layer 5 opacity is $1/5 = 20$ percent; Layer 8 is $1/8 = 16$ percent, and so on.)
7. For a little added punch, Ellen suggests increasing contrast on a couple of images. I use a curve adjustment layer and choose the medium contrast preset from the drop-down box. As you can see in diagram 2, it was done on Layers 4 and 7.
8. The file should be quite large at this point, so it's a good idea to flatten the image, compressing all layers by selecting Layer>Flatten Image, and then save.
9. After changing the final opacity on Layer 10, the layered image will instantly appear, as seen on the following page.

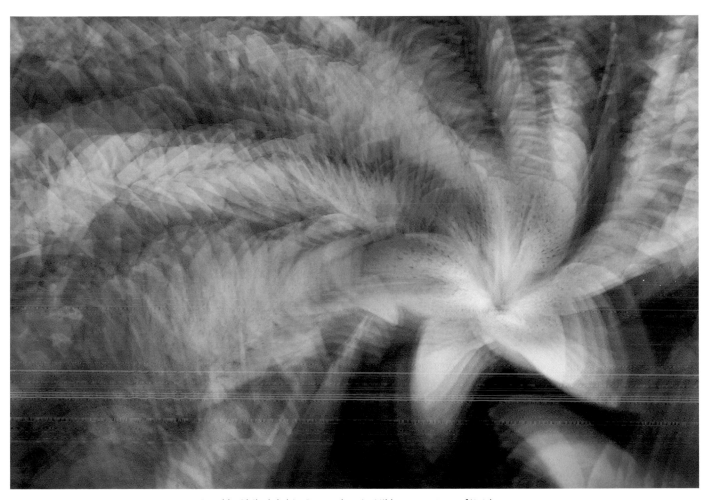

Day lily, Philadelphia, Pennsylvania; Nikkor 24–70mm, f/2.8 lens
Technique—Multiple Exposure Compiled in Photoshop

I want to express my feelings rather than illustrate them.
—Jackson Pollock

Every photographer should have a split nautilus in their studio or home. They are endlessly fascinating and photogenic subjects.

I initially shot this image at ISO100, hand-holding the Nikkor 105mm VR lens, using window light and one hot light to create the subtle side light. The lens and camera were set to autofocus, spot-focusing on the center of the swirl. I made each of the ten exposures by slightly twisting the camera and refocusing on the center of the swirl. I didn't like the clean, sharp look of the low ISO image, so I kept pushing the ISO higher for increased texture and settled on ISO640. This type of instant feedback on experiments facilitates more creative photography.

Modern DSLRs handle high ISO noise well, but for those cameras that don't handle high ISOs well, noise reduction software like Nik Software's Dfine 2.0, Noise Ninja, and Noiseware is quite effective and has very slight to no effect on image sharpness.

It's also good practice to shoot several instances of the same multiple image, one after the other, to get a groove going and to give you options when selecting your favorites of the lot.

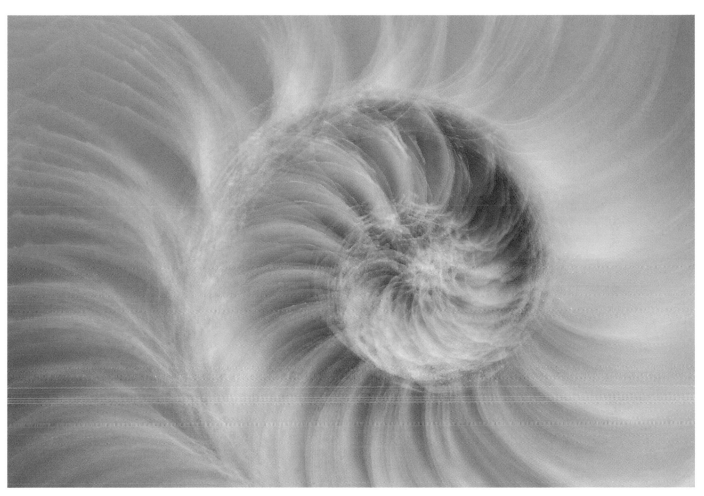

Nautilus, Eldersburg, Maryland; Nikkor 70–200mm, f/2.8 lens; ten exposures

Technique—Multiple Exposure Swirl

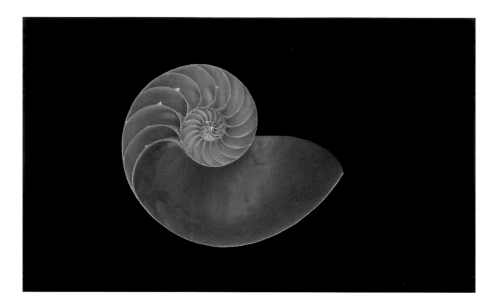

There is debate among photographers in regards to scanographs, or scan art, whether the images produced by this technique are photographs or not. I agree with the latter conclusion. This process consists of placing a subject on a flatbed scanner (leaving the lid up, so you don't crush the subject) and simply creating an image file by scanning. It's a very cool effect. Non-photographers have won photo contests by entering scan art, even in professional photography organizations, but it has absolutely nothing to do with photography. That said, it is a visual interpretation of a subject, still requiring artistic judgment, especially in the cropping and digital treatment techniques after the scan.

The digital sandwich effect was applied to this image to create the soft/dense look. The crop was created to fill the frame with the most graphic and rhythmic part of the nautilus.

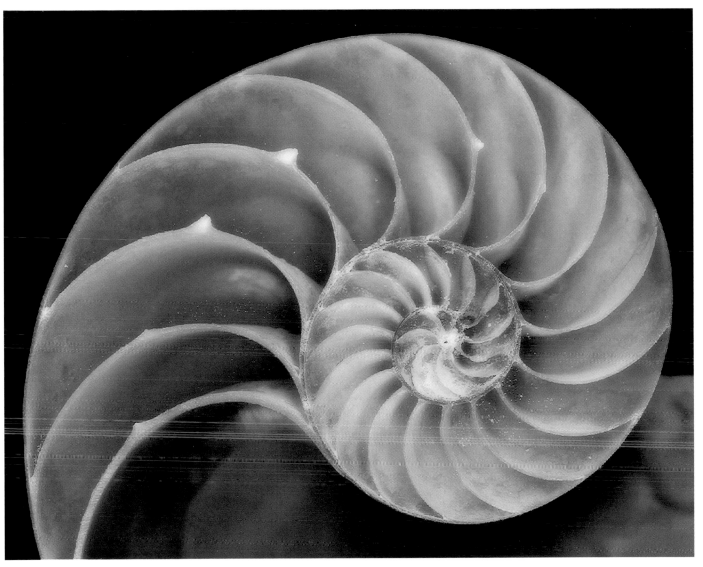

Scanograph, Eldersburg, Maryland; Microtek ArtixScan M1 flatbed scanner

Technique—Digital Sandwich in Photoshop

It's on the strength of observation and reflection that one finds a way. So we must dig and delve unceasingly.

—Claude Monet

This is a very cool camera movement technique. In this fall scene, there was a lot of color, but it was a busy area and was difficult to organize. So I tried various camera movements, hoping to thin out the scene, checking the camera monitor after each exposure to see if the results were heading in the right direction. I tried a series of vertical, diagonal, and horizontal movements at various speeds, but nothing seemed to work. So I took a shot at quick circular movements. It became apparent that the exposure wasn't long enough to complete the circle, which turned out to be a happy accident. The exposure time revealed only a portion of the circle, which I now refer to as "cups." The look of the "cup technique" can vary depending on where you begin the circle, the size of the circle, and the speed and direction of the movement.

This image was made in the greatest concentration of color by beginning a circular movement in a quick downward arc from left to right. The length of the exposure didn't allow for completion of the circle, as mentioned earlier, but did blend the colors nicely and added breadth to the birch tree trunks. It's a good work practice to shoot a bunch of these types of images until you get into a groove and get a feel for the timing of your movement, always checking the camera monitor to fine-tune the composition.

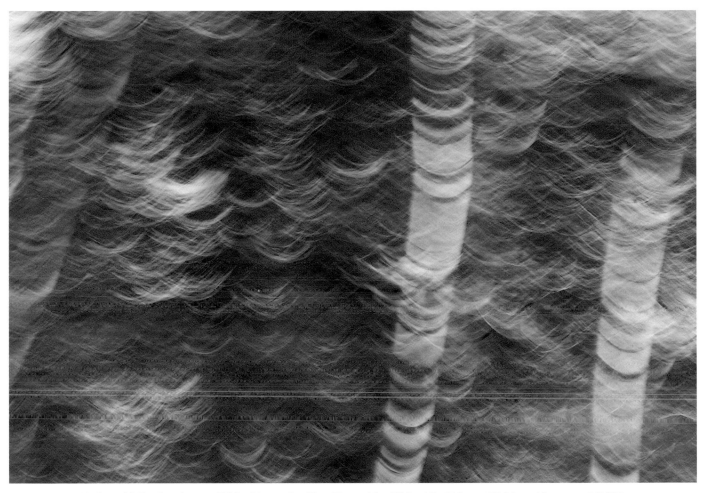

Birch and fall color abstract, White Mountains, New Hampshire; Nikkor 70–200mm, f/2.8 lens; $1/20$ second @ f/22

Technique—Camera Movement "Cup Technique"

A work of art which did not begin in emotion is not art.
 —Paul Cézanne

The Lensbaby is a tremendous creative tool that many photographers use in their creative and professional work. Lensbaby images appear in the catalogs of major stock agencies as well as on covers of major magazines. Owners of Lensbabies are aware of the bending technique they use to get selective focus or defocus with exaggerated edge blur. But you can use a little-known technique to allow closer focusing than normal—push the Lensbaby out instead of keeping the lens in its default position or pulling and bending the lens.

This technique is particularly valuable when flowers are very close together and you want to blur the background. By hand-holding the lens and moving in to only get the tips of the foremost flower (relatively) sharp using an f/4 aperture ring, all color beyond that point becomes a blur even though the flowers are very close together.

Several exposures were made of this image. Only one came out with the appropriate sharpness and soft background color.

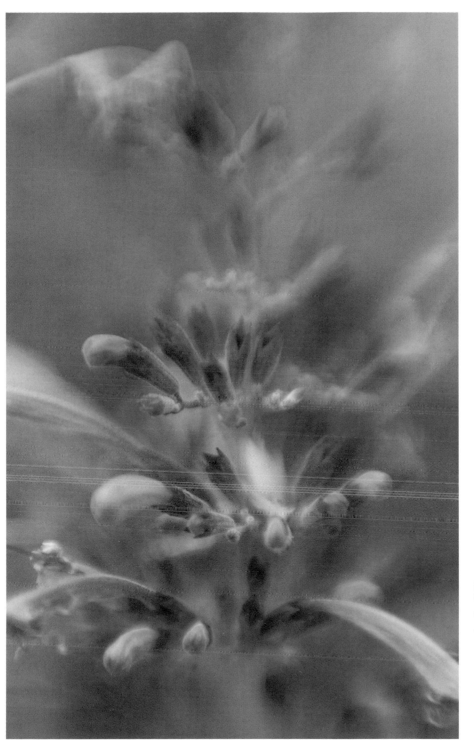

Soft pastel, Whidbey Island,
Washington; Lensbaby 3G,
wide open

Technique—Push Lensbaby Out

The subject comes first, the medium second.
—Richard Prince

I prefer to use curve adjustment layers for manipulating the contrast of an image, but using a levels adjustment layer on some images is a bit more expedient and gives me what I'm looking for. The flatness of the RAW image is indicative of using a Singh-Ray Tony Sweet Soft-Ray filter to get more of a fantasy feeling evoked by this incredible scene at Magnolia Gardens, outside of Charleston, South Carolina. As you can see from the levels, the curve is almost in the middle of the graph. By moving the left triangle up to where the curve begins, the image darkens. I actually went a little beyond that point (personal preference). I left the right triangle untouched since moving it in would lighten the image. In order to increase contrast, I moved the mid-tone slider to the right to .75. The resulting image maintains the soft mystical feel, but with added contrast, density, and color intensity.

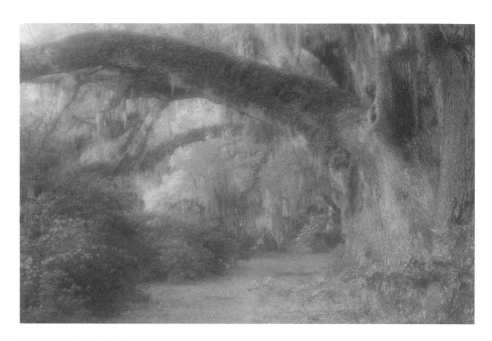

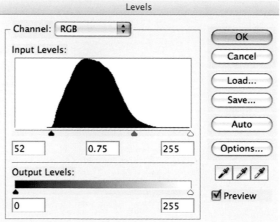

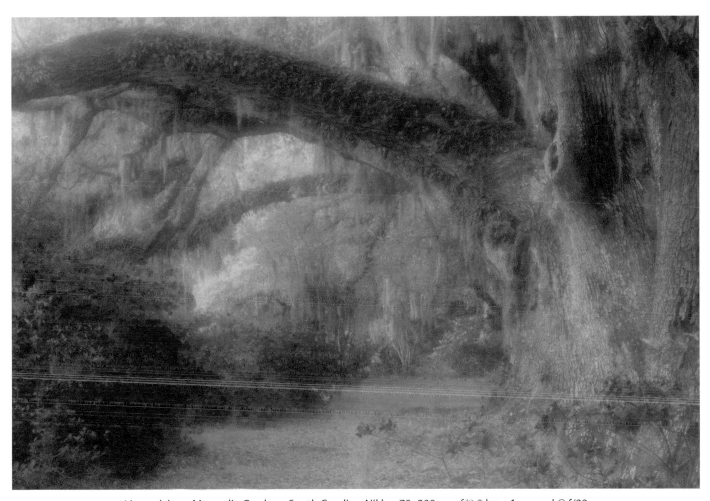

Live oak lane, Magnolia Gardens, South Carolina; Nikkor 70–200mm, f/2.8 lens; 1 second @ f/22

Technique—Singh-Ray Tony Sweet Soft-Ray Filter and Levels Adjustment

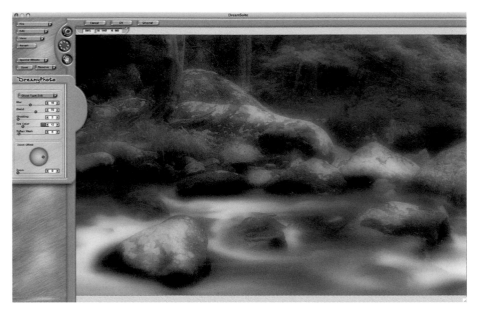

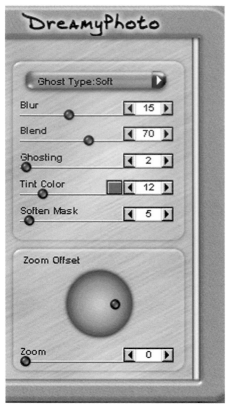

Auto FX has this very cool (free sample) plug-in filter in its Dreamy Filter Series, appropriately called DreamyPhoto. Select this filter in the filters menu in Photoshop. By pressing the special effects button, you'll see a series of controls under the DreamyPhoto title script. In this image, I left the settings at the defaults shown above, but blur, blend, ghosting, tint, and soften mask are available to further control the effects to taste. There are no standard settings. As with most plug-ins, it's always best to begin by experimenting with the extreme settings to get a sense of the possibilities, then back off and use smaller moves until you get what you like. The more you do this, the more skilled you will get at achieving a desired look. This particular filter was chosen for this image because of the soft glow rendered in the entire image, most notably in the flowing water.

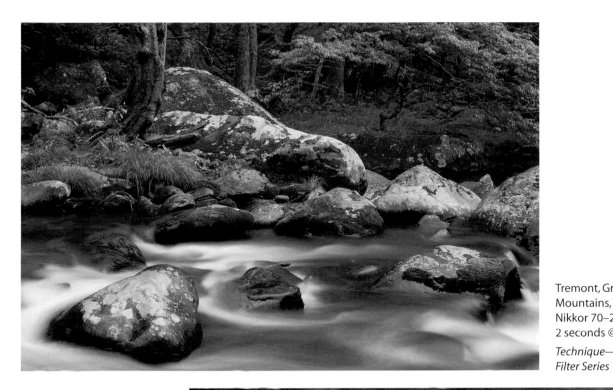

Tremont, Great Smoky
Mountains, Tennessee;
Nikkor 70–200mm, f/2.8 lens;
2 seconds @ f/22

*Technique—Auto FX Dreamy
Filter Series*

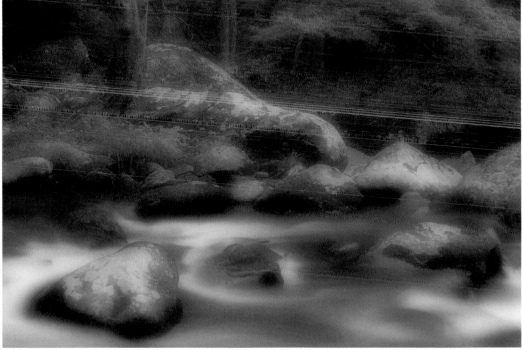

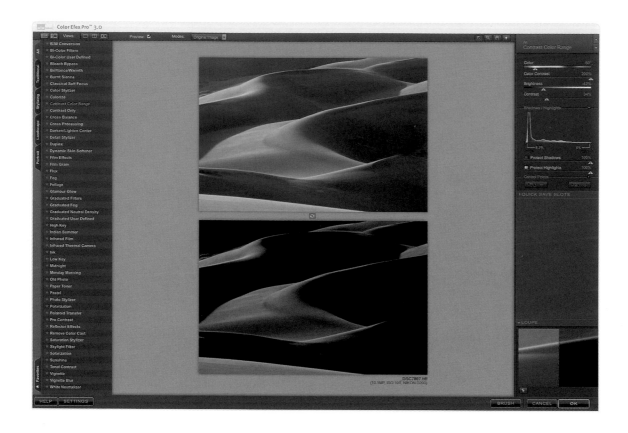

During marginal times of day, sand dunes are wonderful photographic subjects, replete with interpretive options. The Color Contrast Range filter by Nik is a great tool for these types of situations. This late afternoon dunes image from the Great Sand Dunes in Colorado lends itself well for this filter. Increasing color contrast all the way to 200 brought out the edges of the dunes and added a warm glow. The increased contrast and decreased brightness deeply darkened the shadow areas, accentuating the rolling rhythm.

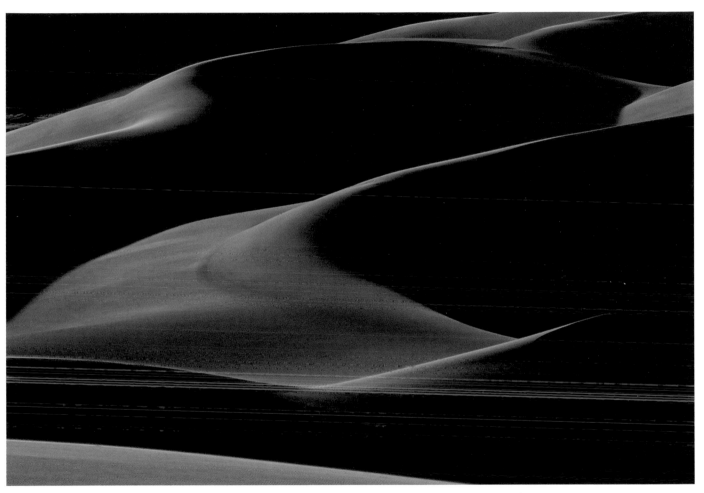

Great Sand Dunes, Colorado; Nikkor 70–200mm, f/2.8 lens; 2 seconds @ f/22

Technique—Nik's Contrast Color Range Filter

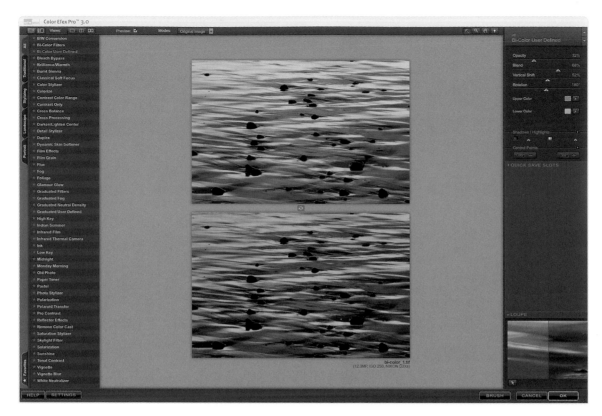

There was a hint of color in this wet sand and rocks pattern in La Push, Washington. But the light was flat and the scene lacked impact. Normally, I would use a gold/blue polarizer on this type of scene to accentuate the warm and cool tonalities. However, in this case, I chose the Nik Bi-color User Defined filter, using the eyedropper to custom select cool and warm tonalities. The final color selection was too harsh and unnatural, so after dropping the opacity to 60 percent (top of the layers palette), the effect was toned down to taste.

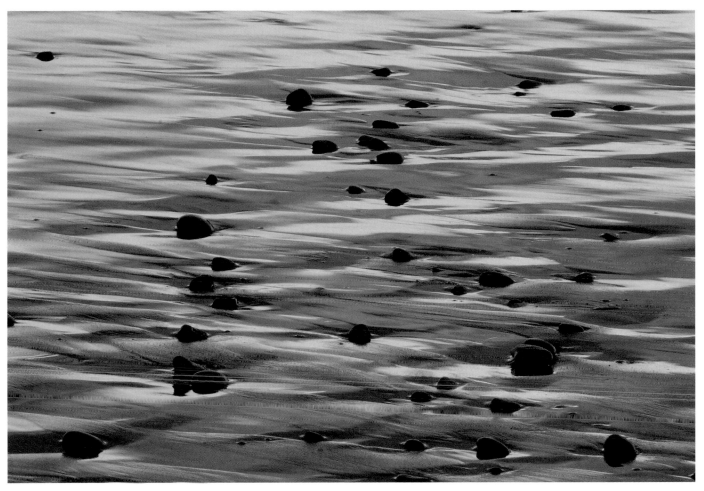

La Push, Washington; Nikkor 24–70mm, f/2.8 lens; 1 second @ f/22
Technique—Nik's Bi-Color User Defined Filter

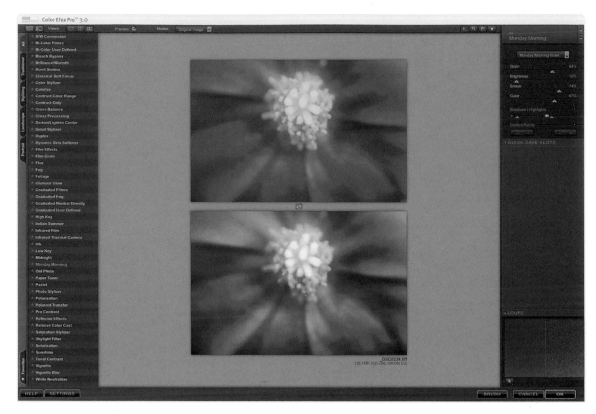

Normally, I use the Lensbaby 3G (the most current version at this writing) with large aperture rings, or I just leave it wide open. An instance where different settings are necessary is when you shoot at very high magnification, where depth of field is minimal, even at f/22. Here the falloff is quick, just like with a normal lens, and the f/16 aperture ring brings in the stamen to crisp sharpness. After sharpening the image to my liking, I painted in the petals with Nik's Monday Morning filter to enhance the texture. The purple color was brought back by increasing color in the Nik filter control panel. Smear and grain are turned up to increase the texture and grain of the image. As you can see from the layers palette, the only element not painted in was the stamen.

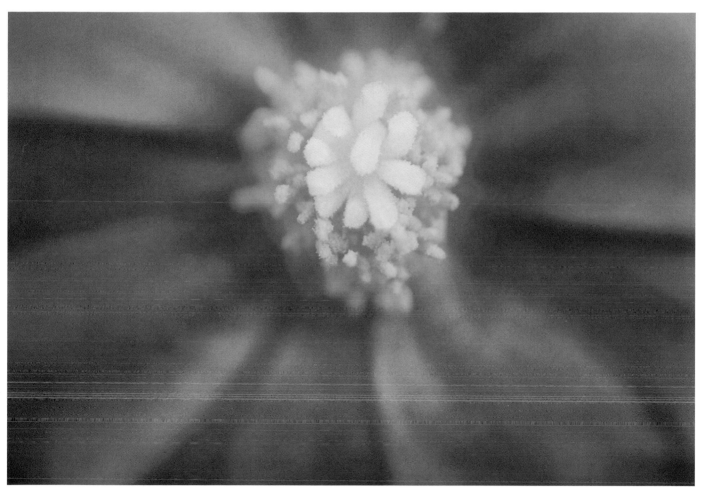

Flower portrait, Baltimore Conservatory, Maryland; Lensbaby 3G, 10X close-up filter, 8mm extension tube; 2 seconds @ f/22

Technique—Nik's Monday Morning Filter

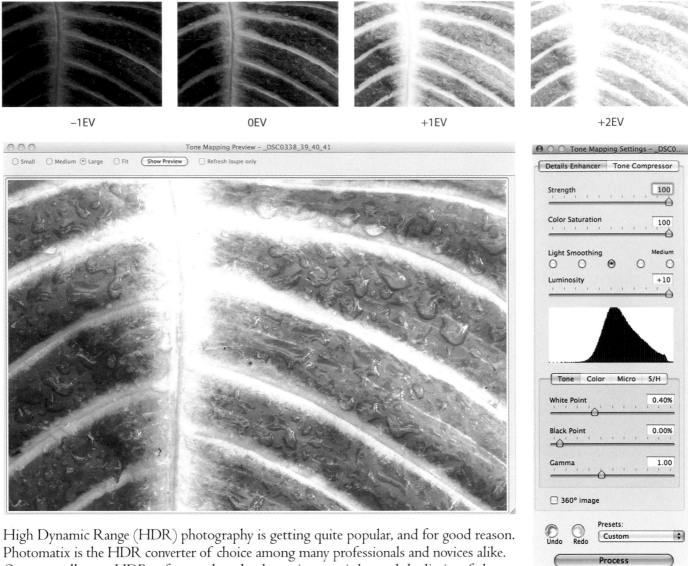

−1EV 0EV +1EV +2EV

High Dynamic Range (HDR) photography is getting quite popular, and for good reason. Photomatix is the HDR converter of choice among many professionals and novices alike. One normally uses HDR software when the dynamic range is beyond the limits of the camera; for example, when you shoot from inside of a building, where metering for the inside will render blown-out windows. In the case of this leaf, the light was very uneven. The four exposures above were made at −1EV, 0EV, +1EV, and +2EV so that when combined in Photomatix, the lighting would be even on the leaf. The Tone Mapping Preview is actually the RAW HDR image. After you open the tone-mapping dialogue box, the RAW image changes to the settings in the dialogue box, which are the settings on the previous image. After I further adjusted the image to taste, I got the image on the opposite page as a result. Notice how the added saturation, texture, evenness of light, and imperfections were cloned out.

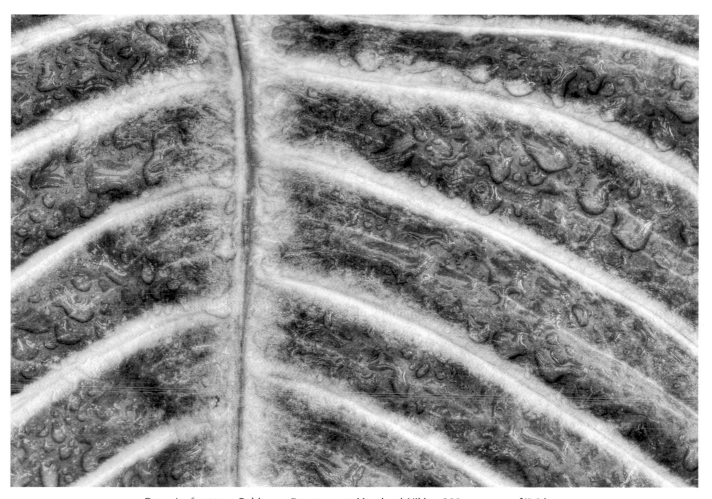

Dewy leaf pattern, Baltimore Conservancy, Maryland; Nikkor 200mm macro, f/2.8 lens

Technique—Photomatix HDR

Technology, like art, is a soaring exercise of the human imagination.
—Daniel Bell

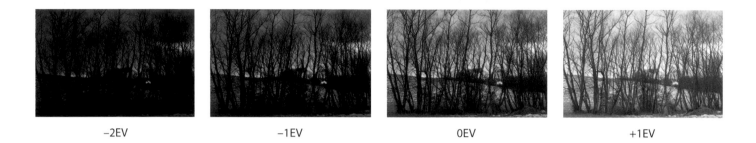

| −2EV | −1EV | 0EV | +1EV |

This is a classic example of using Photomatix to record a scene where the dynamic range of the light is beyond the camera's ability to record it naturally. If the trees weren't there, this would be a quick and easy shot using a four-stop grad ND filter. But, as you can see from the image sequence above, it's the classic light trade-off: If the foreground is recorded well, as in our +1EV example, then the sky is a bit washed out and the sun loses its rich warm tone. If the sky is recorded well, as in our −1EV example, then the foreground is too dark and merges with the blocked-up trees below the hillside line. The −2EV image was made to darken the orange of the sun and to bring all highlights in from the right edge of the histogram, thereby guaranteeing detail in the shadows and in the highlights. As you can see in this image, there is detail in the tree bark and the sky maintains its rich dusk tonality.

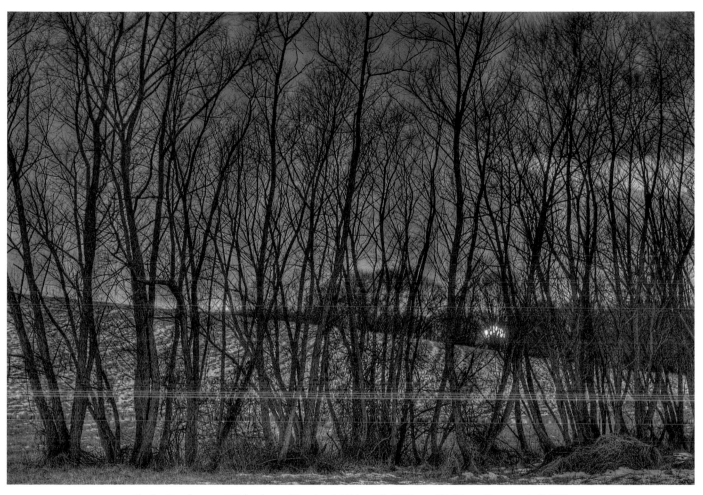

Slacks Road sunset, Eldersburg, Maryland; Nikkor 70–200mm, f/2.8 lens; 2 seconds @ f/22

Technique—Photomatix HDR

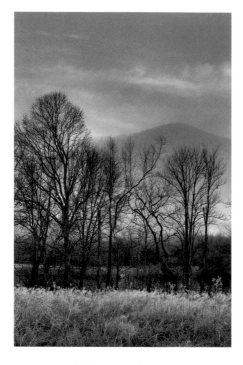

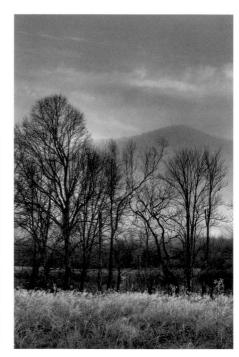

Because of the great dynamic range between the foreground hoarfrost and the bright sky and warm mountain top, this image was made by photographing a 5-exposure HDR image (+2EV, +1EV, 0EV, –1EV, –2EV) and combining the results in Photomatix HDR software. Using Nik Software's Viveza Photoshop plug-in, I was able to selectively punch up the warm mountain tonality. Viveza uses Nik's U-Point technology, which enables four very targeted color controls. The top control selects the area that will be affected by the adjustments, and the bottom three controls are for brightness, contrast, and saturation. Notice on the top images I placed the points in the mountain, setting the faders to greatly increase saturation and to mildly increase brightness and contrast. You can see the results in the top right image. The sky was a bit flat, so I positioned the U-Points in the sky and increased the area to cover the sky entirely. I slightly decreased brightness and increased saturation. The settings are shown at the bottom right. After punching up the warm color on the mountaintop and darkening and saturating the sky, I present the final result on the opposite page.

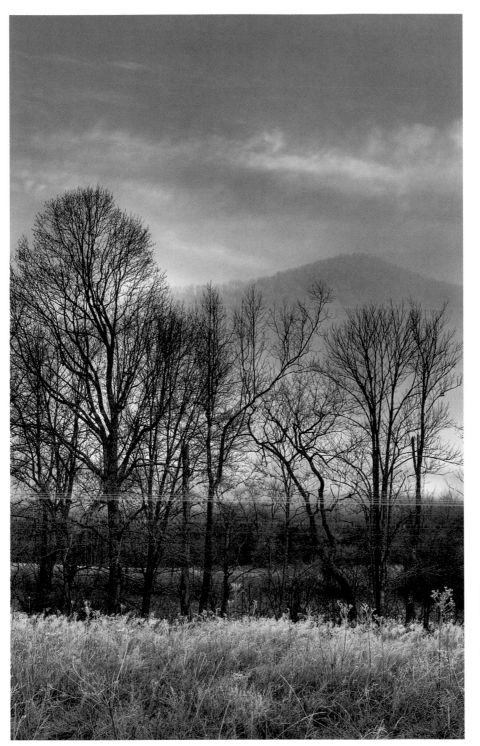

Hoarfrost at dawn;
Nikkor 24–70mm, f/2.8 lens;
$1/2$ second @ f/22

*Technique—Photomatix HDR
and Nik Viveza Plug-in*

This final image is an example of when I find shooting in HDR indispensable. Notice on all of the five HDR images to the right that none of them come close to being useful. Generating an HDR image from these renders the HDR RAW image (below), which I save as an .hdr file so that I don't have to reprocess it if I want to work on it in a later version of Photomatix. After pressing the tone-mapping button, the image changes dramatically. At the bottom of the tone-mapping box is the presets drop-down menu, where I normally choose "default" to start an image from scratch.

I've already applied the tone-mapping adjustments to the image on the top of the next page. The image is more colorful and the shadows are opened up, but there are still some elements to address as the image is a bit flat. I applied Nik's White Neutralizer by clicking on the orchids to the left, removing the pinkish cast. Then I applied three curve adjustment layers to slightly increase contrast, brightness, and hue/saturation in the entire image. After these alterations, the orchids still weren't quite right. On the final image at the bottom right, I selected Nik's Viveza plug-in and clicked on the largest orchid petal, selecting the orchid area only. By increasing brightness and contrast to taste, the orchids popped as I remembered them, rendering proper exposure throughout this high dynamic range image.

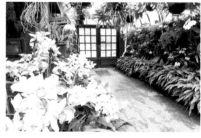

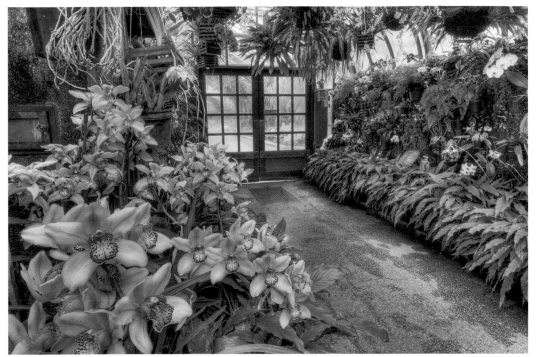

Orchid room, Kennett
Square, Pennsylvania;
Nikkor 12–24mm, f/2.8 lens

*Technique—Photomatix HDR
and Nik Viveza Plug-in*

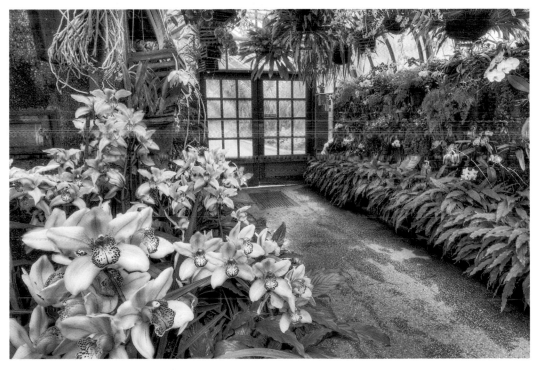

Glossary

Adjustment layer—An image layer on top of the original image. It enables you to adjust exposure, contrast, saturation, and other effects without affecting the original image.

Blend mode—Photoshop settings that define how layers react with each other.

Blocked up—When shadows are so dark that they lack any detail (information).

Blown out—When highlights are so bright that they lack any detail.

Canon 500D filter—Hardware filter that enables telephoto and macro lenses to focus closer than the minimum focusing distance, creating higher magnifications and soft backgrounds.

Contrast curve—An S-curve that adds contrast to the mid-tones. There are three preset contrast curves available in the curves menu in Photoshop CS3: linear contrast, medium contrast, and strong contrast.

Curves—A Photoshop tool used to redistribute tones in an image by adjusting a diagonal line on a grid using any number of anchor points to create a tonal curve.

Digital Single Lens Reflex camera (DSLR)—Any digital camera that can use interchangeable lenses.

Drop-down menu—A menu of options that appears below the item when the user clicks on it.

Exposure Value (EV)—A constant value of light achieved through any linear combination of aperture and shutter speed. For example, at an EV value of 0, f/3.5 at $^1/_{30}$ is equal to f/4 at $^1/_{60}$, f/4.5 at $^1/_{50}$, and so on. EV is useful for exposure compensation. At any combination of aperture and shutter speed, one can +/− several stops to fine-tune exposure (+1EV, −1EV, etc.).

Feathering—A Photoshop term meaning to round the edges of a selection and also blend the selection with the non-selected area.

Gold/blue polarizer—A polarizer that, when rotated, changes light-reflecting areas from blue to golden tones, adding color to the scene.

Graduated Neutral Density filter (Grad ND)—A hardware filter that reduces light in only the top or bottom section of the frame in order to achieve an even exposure. For example, one would be used to hold back a bright sky while properly exposing for the dark foreground.

Grunge—An illustrative effect that can be applied to images in Photomatix. Achieved by turning off all smoothing sliders.

High Dynamic Range (HDR)—A photographic technique involving combining images taken at different exposures to increase the dynamic range of a scene.

Hue/Saturation—Hue is a color or shade. Saturation is the dominance of hue. You'll mostly deal with the Saturation part of this dialogue box.

Image overlay—A technique where a second image is placed on top of the first and the opacity is lowered so both images can be seen simultaneously.

In-camera—An effect that can be performed when taking the picture. For example, some cameras can perform multiple exposures using a custom setting.

Kelvin—In regards to photography, it is a unit increment of color temperature used to determine white balance. The color temperature of daylight is approximately 5500K. The Kelvin range is from 2500K (very blue) to 10,000K (very warm).

Levels—A Photoshop feature to expand the dynamic range of colors and tones in an image, as well as set black/white points and control brightness without affecting highlights or shadows.

Multiple exposure—A photographic technique where two or more images are taken in the same frame. This effect can be reproduced in Photoshop.

Neutral Density filter (ND)—A hardware filter that reduces all wavelengths of light, allowing for longer exposures or higher aperture settings.

Noise—When using a high ISO or shooting in low lighting to maximize available light, background static is also amplified, creating noise, or grain, especially in the shadow areas.

Nudge—To make incremental movements of a selection in Photoshop by using arrow keys.

Opacity—The amount of transparency attributed to a layer. The lower the percentage, the more transparent the layer.

Panning—A photographic technique to keep a moving subject sharp while creating a blurred background. Achieved by moving the camera along with a moving subject, keeping the subject in the same position of the frame for the duration of an exposure.

Photomerge—A Photoshop function used to create panoramic images by stitching several pictures together.

Plug-in—A third-party program that interacts with an application to provide additional capabilities and specific, automatic functions.

RAW—An unprocessed image file containing the maximum amount of data from a digital sensor.

Sandwiching—A technique that combines two images, one image overexposed and one image blurred to create a dreamy look.

Scanograph—A digital image created with a scanner.

Swipe—A photographic technique in which the camera is moved rapidly.

Tony Sweet Soft-Ray filter—A filter that creates a soft/painterly effect that is enhanced in bright light, which creates a glow.

Tripod collar—A ring that attaches between a large lens and the camera body that mounts to a tripod.

U-Point—Nik Software technology that uses control points to achieve quick image adjustments without the use of masks, layers, or other complex procedures.

Variable Neutral Density filter (Vari-ND filter)—A filter made of two glass disks that get darker as they are rotated so that exposure can be increased significantly, even in bright sunlight.

Product Links

Alien Skin Exposure—http://alienskin.com
Auto FX—http://www.autofx.com
Helicon Focus—http://www.heliconsoft.com
Life Pixel—http://lifepixel.com
Nik Software—http://www.niksoftware.com
Photomatix—http://hdrsoft.com
Photoshop CS3—http://www.adobe.com
Velvia Vision—http://www.fredmiranda.com

Equipment

Cameras

Nikon D3 and D300

Nikon D200 converted to dedicated digital infrared

Lenses

Nikkor 50mm, f/1.4

Nikkor 12–24, f/2.8

Nikkor 16mm fish-eye, f/2.8

Nikkor 12–24mm, f/2.8

Nikkor 24–70mm, f/2.8

Nikkor 70–200mm, f/2.8

Nikkor 300mm, f/4

Nikkor 85mm, f/1.4

Nikkor 85mm tilt/shift, f/2.8

Nikkor 105mm macro, f/2.8

Nikkor 200mm macro, f/4

Lensbaby f/2.8, f/2.0, 3G

Glass Filters and Accessories

Singh-Ray ColorCombo filter

Singh-Ray Warming Polarizer

Singh-Ray 10 magenta filter

Singh-Ray Vari-ND filter

Singh-Ray Vari-N-Duo filter

Singh-Ray Tony Sweet Soft-Ray Diffusion filter

Singh-Ray Gold-N-Blue Polarizer

Singh-Ray 2–5 stop soft and hard edge Grad ND's

Canon 500D close-up filter

Nikkor 1.7x and 1.4x teleconverters

Promaster auto extension tubes 12mm, 20mm, 36mm

Nikon 8mm extension tube

Lensbaby wide angle, telephoto, and close-up attachments

Lowe Pro Vertex AW backpack

RPS studio lights for macro studio

Gitzo GT 3540XLS

Really Right Stuff L-brackets and BH-55 and BH-40 tripod heads

Arca Swiss B-1 tripod head

Nikon SB800 and R1C1 flash units

Digital Work Station

MacPro 2.66 GHz Dual Core Intel Xeon, 8 GB RAM

Dual displays, Apple flat panel 23" and 20"

MacBook Pro laptop, 15", 4 GB RAM

Black MacBook, 13", 2 GB RAM

Microtek ArtixScan M1

Microtek CX6 Plus DLP digital projector

Nikon 4000 Super Coolscan

Nikon 9000 Super Coolscan

Epson Printers—7600 and 3800

Paper—We exclusively use Museo Fine Art papers and card stock

Lacie RAID and other various Lacie and Seagate external hard drives

Primary Software

Aperture

Adobe CS3—Photoshop, Image Design, Dreamweaver

Nik Software—Color Efex 3.0, Viveza, Dfine 2.0, Nik Sharpener

Alien Skin Software—Exposure 2 and Snap Art

Photomatix

Helicon Focus

Apple's iWeb blog software

Expression Media

SilverFast scanning software

Web host: macserve.net

Acknowledgments

I FEEL LUCKY TO HAVE MET AND GOTTEN TO KNOW MANY GREAT PEOPLE IN this business.

Here's a partial list of photographers, friends, and associates who continue to enrich my life:

Pat O'Hara, Nancy Rotenburg, Ellen and Jack Anon, Brenda Tharpe, William Neill, John Shaw, Jim Zuckerman, George Schaub, Jim Miotke, Bill Lea, Adam Jones, Jim White, Eddie Tapp, Artie Morris, Bryan Peterson, Charlie Needle, Donny McGowen, Don Nelson, Tony Gayhart, Jack and Rose Kennealy, Mark Menditto, Greg McKean, Josh Taylor, Corey Hilz, Bob Ihrig, Ron Levi, Ferrell McCollough, Dr. Bob Singh, Weir McBride, Barry Tannenbaum, Tony Corbell, Karen Hart, Lydia Thomas, Janice Wendt, Bob Tope, Joe Ventura, Sam Pardue, Rick Roeder and Iris Benjamin, Mike Leventhal, Sally and Clark Murphy, Barb and Phred Williams, IndoBon, Mary Nemuth, The Wrecking Crew (Sara, Karen, Holley), Liz and Frank Lawlor, Timmy "jesus" McGinley, John Barclay, Bill Strom, the late Gary Hong, and the late Phil Cunningham.

Special thanks to Kelly Gilmartin and to Susan Milestone for their invaluable help and suggestions during the creation of this project.

Special thanks to Mark Allison and the great people at Stackpole Books for their continued support throughout the *Fine Art Photography* series.

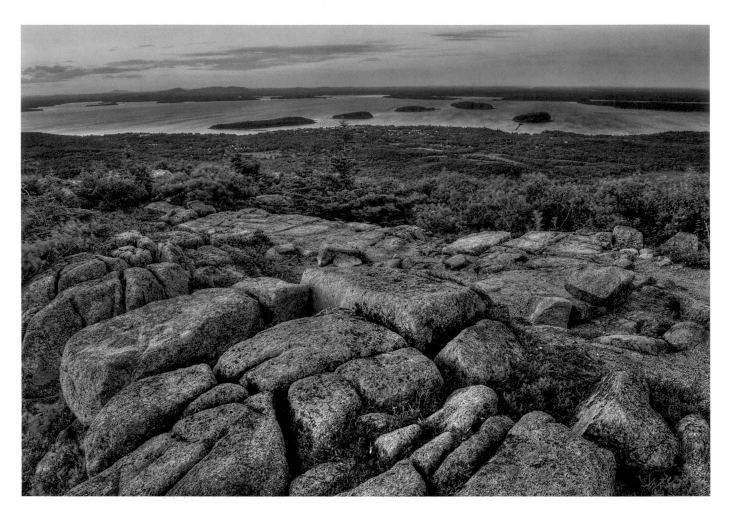

Information about limited-edition prints of Tony Sweet's images and details about the photography workshops he offers are available on the author's Web site, www.tonysweet.com, or by e-mail at tony@tonysweet.com.